From the author of 'Black Beauty'

Obama
101 Best
Covers

A Commemorative Collection

Ben Arogundade

White Labels Books

LONDON TOWN

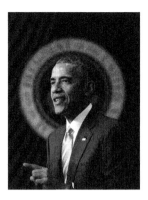

Obama: 101 Best Covers: A Commemorative Collection
First published in 2017 by White Labels Books.
www.whitelabelsbooks.com
Copyright ©Ben Arogundade, 2016.

ISBN 978-1-9998351-1-8

Email: enquiries@whitelabelsbooks.com
Twitter: @WhiteLabelsBook @BArogundade

Written, art directed and designed by Ben Arogundade.
Typeset in Adobe Garamond Pro and Helvetica Neue.

Cover image by Alex Wong. ©Alex Wong/Getty Images.

Our books are made-to-order using print-on-demand technology. This means less paper, less waste and reduced transport costs. Our motto is, content first, format second.

Printed by IngramSpark.
Available from Amazon.com, CreateSpace.com, IngramSpark and other retail outlets.

Thanks you guys:

Zak Arogundade, Jacqueline Adams, Sue Amaradivakara, Beverly Anderson, Anthea Barbary, Antoine Ebelle-Ebanda, Mark Gambarota, Elizabeth Gessel, Noel Gordon, Jeanette Gorgas, Ian Haynes, Yvette Hollingsworth Clark, Nancy Lane, Wayne Mitchell, Anna Murphy, Angie Parker, Sheila Talton, Mike Webster, Nicole Zimmermann.

'You The King Now, Baby'

The idea for this book was seeded on the night of November 4, 2008. Ben Arogundade was amongst the crowd shown here that had gathered in Times Square, New York, on Election Day, to witness Barack Obama's historic victory as the country's first African American president. This is the author's account of that evening's dramatic and unforgettable event.

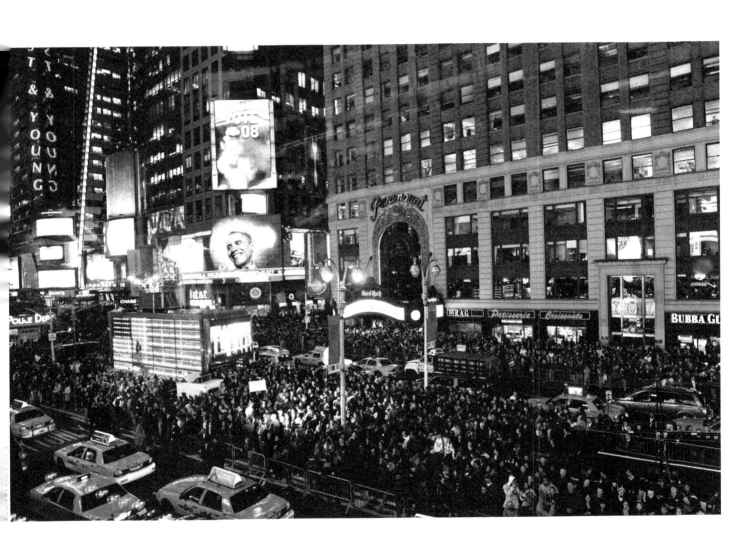

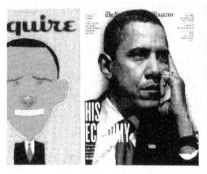
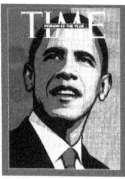
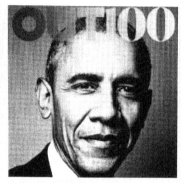
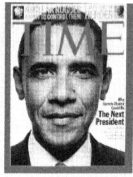

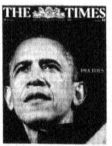

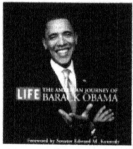

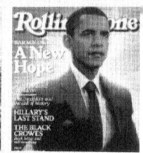
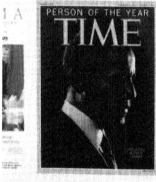

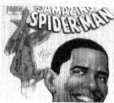

"*Alright! Alright! Alright! Alright! Alright!*" said the pretty blonde, perky as a cheerleader, as she stepped briskly along the line of roadside revellers, high-fiving strangers as if they were all members of some imaginary football team. This is what these kinds of events do to people — release their muffled extroversion, metamorphose them temporarily into wilder facsimiles of themselves, their normal streetwise caution stripped away for that night.

There were thousands of shining eyes in the square, eyes that were once hopeful, that were once fearful of a possible future in which he did not win, eyes that were now shimmering with joy. There was nothing to tell them apart, not a hint of nationality in their glossy extraction. Who could tell which eyes in the crowd were English eyes, or Spanish eyes, or French eyes or New York eyes?

Clasped between their fingers many held miniature American flags, full of new symbolism, each vibrating fast and light in the gentle night air. The zone above the crowd was filled with digital cameras and mobiles, hovering like an invasion of miniature UFO's, their silvery lenses recording the entire panorama. Today it is their imagery that defines our history. People are the real historians now.

The gridlocked traffic was honking loudly. But that night the sound possessed none of the impatience it usually does. That night this seminal sound of New York City rang out as sweetly as a chorus of trumpets, their tone somehow not as shrill as we know it to be on ordinary days, as it rebounds off the concrete, glass and steel surround of this corridor-shaped metropolis. Motorists sat fixed, their seats now armchairs, their windscreens now television screens, happy to be gridlocked for once, for this occasion only, happy to be going nowhere. Where else could anybody possibly go right now that would

be better than right here in Times Square on election night?

The massed crowd were hemmed in by the flat fronts of the architecture, corralled and pressed into a single huge body of life and thought and energy. Then came their collective noise, a chant, spreading through the crowd, swelling like a sonic tsunami — "O-BA-MA!, O-BA-MA!, O-BA-MA!, O-BA-MA!," in dozens of different accents from around the world. The crowd thrust their fists into the air as they sang, punching out each of the three syllables of the new president's surname as if they were hammering on an imaginary xylophone. Nowhere outside of a sports stadium or concert hall have I heard so many white people chanting a black man's name.

But the pre-eminent sound of the night was not the chanting of Obama's name, nor the incessant honking of car horns; it was the sound of revellers howling with joy, a mass vocalisation which manifested in a single long drawn out note undulating in the night air — a "*Whooooooooooooooooooooooooo!*" — like the sound of wailing wolves.

And then amongst it all, a middle-aged African American woman, marveling at the scenes of euphoria before her, turned to her partner, smirked and asked, "Did they do all this when Bush got elected?"

I SHOULD HAVE BEEN IN LONDON that night. It was pure chance that I was in America to witness the historic scene in Times Square. I'd arrived in New York City that very day, for the purpose of promoting a book I had been working on, and the dates just happened to coincide. I was embarrassed that I had not organised the trip specially for such an historic occasion as the triumph of the country's first African American president.

Earlier that evening, after working most of the afternoon, I

felt heavy and slow, and soon developed a headache. I returned to the hotel to have a quick nap in the hope that I might shake it off. I turned on the television and put on the election coverage, then dozed off as the first results began to trickle in.

I woke up later than expected. I glanced at the TV screen and saw six words:

Barack Obama is the new president

I fell back into a slumber, certain that it was all a dream. There was no way a black man could be king of America. No way. When I awoke again a few minutes later, the words were still there at the bottom of the screen. I ebbed and flowed in and out of consciousness until finally I snapped awake. It was true. Barack Obama had won. He'd won.

After centuries of all white presidents — a consecutive lineage of 43 to be exact — suddenly there was a black one. It was like an explosion. It was the biggest single change America had ever seen.

I sat up, groggy, my eyes stinging. I still felt ill, but elated. I was determined to go outside and be amongst the revellers, to be a part of history unfolding. My hotel was on West Forty-Seventh Street, just yards from Times Square. I hauled myself out of bed, splashed my face with water and ventured outside.

It was a warm night, and the atmosphere in the square was electric. It was like Mardi Gras, New Year's Eve and a championship sports event all rolled into one. The crowd were as frenzied as if the new president was standing right here before them instead of 700 miles away in Chicago. As I

mingled amongst the Americans in the crowd, no one knew that I wasn't one of them — that I was an Englishman in New York — and I felt good about that, because at that moment I felt that I wanted to be an American, I wanted to be a part of this new era. There were thousands of other foreigners present too who no doubt felt the same way; world citizens everywhere — people who cared enough about this new America to have made a special effort to be here to celebrate the coming of a president of a country that was not even theirs. But that was the point — we all felt a little bit like Obama was ours — the French, the Dutch, the Spanish, the English, the Asians.

I was struck by the global synchronicity of the festivities — that thanks to modern communications I was celebrating at exactly the same moment as millions of others around the world — from Kensington in London to Kisumu in Kenya. The simultaneous celebrations and parties that took place all over the world made it seem as if Obama had just won president of the world instead of the United States.

As I watched people kissing and embracing each other I suddenly felt a sense of loneliness. I was on my own, with no one I loved by my side to share this unique moment with. I thought of my then fourteen-year-old son Zak, and how great it would have been if he had been here with me, our arms locked around each other's shoulders in unified celebration. In a sense I was surprised at my feelings of loneliness, considering where I was — New York — a humming 24-hour metropolis where loneliness often seems impossible, with the constancy of people and traffic and noise.

At the edge of the crowd I spotted a lean dude wearing

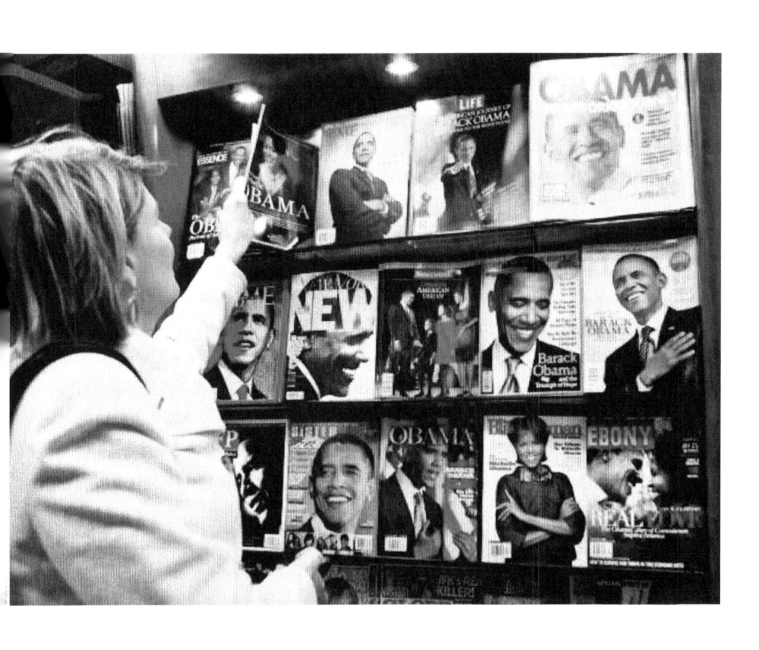

mirrored aviator shades and a black leather bomber jacket, doing a brisk trade selling "official" Obama condoms from tray held by a strap around his neck, like a cinema usher. This was the city's biggest night for sex for years. After 911 New Yorkers experienced so-called "terror sex", but tonight here was "Obama sex" — the sex of celebration. How many O-babies, conceived on that electric evening, are out there right now?

Passing me, a posse of young men bounced through the crowd singing his name, wearing Obama badges and hats, holding placards aloft. On any other day such a mob would send onlookers scurrying fearfully for cover, but tonight they cheered them on instead.

I turned and saw an excited brunette, all bendy and flirty, posing for a photograph with a cop. Her slender body contrasted against his solid, heavy-set frame. She wore a shiny dress split all the way up one thigh, and she hitched her bare leg up against him like a showgirl. He put his arm around her and grinned obediently, as if having someone rub up against him was all part if his civic duty.

And then a young brother with a sleek face pointed mockingly at a group of nearby cops and called out to his homies, "Yo, their new commander-in-chief is black. Ha!"

Behind me, three excited young faces huddled together, talking loudly into the lens of a tourist's video camera as if they were live on CNN, jostling for their reality moment.

The atmosphere was such that even statements of naïve optimism passed unchallenged. One reveller shouted, "It's the end of racism, man!"

A woman in the crowd stated the obvious. "This is history in the making," she said earnestly. But somehow in the supercharged atmosphere, her statement didn't sound corny, it sounded exactly right.

I glanced up and saw the image of civil rights icon Jesse Jackson's tears flash up on one of the big screens set up around the square — his face big, his tears now giant tears of joy and disbelief, each droplet now swelled to the size of a person's head. This sight seemed to ignite the most sensitive amongst the crowd, including a large middle-aged woman who joined in, crying with her own pained expression, her whole body shaking feverishly. Everybody present seemed to be releasing something, some energy that had been pent up inside them for who knows how long, perhaps their entire lives.

As the pictures of a victorious Obama returned to the screen, a stocky young hip-hopper in baggy jeans and leather jacket glanced up at the picture of the president-elect, pointed slowly upwards and said — in a regal tone like the actor Ving Rhames as Marsellus Wallace in *Pulp Fiction* — "You the king now, baby. You the king."

And then it was over, and people suddenly didn't seem to know what to do. As the crowd began to disperse, many looked lost, a loneliness returning to their faces as they realised that now, in those grim seconds, they would have to revert to the chilly realities of their own lives and the problems that went with them. People wanted the Obama pre-election train to go on and on because it provided a perpetual sense of expectation, daily excitement and giddy nervousness. As long as Obama hadn't won, the speculation, the will-he-won't-he-win, could go on and on, like a version of *Groundhog Day*. But now it really was over — and yet it was just beginning.

In my excitement to be amongst the crowd I'd forgotten my camera back at the hotel. I had recorded no footage of the amazing scenes I'd witnessed. I cursed myself. What would I show my friends and family to commemorate the fact that I was actually here, witnessing and experiencing history? I was compelled to write down what I had seen instead. It was the only way. I rushed back to the hotel and frantically scribbled down everything I could recollect until I ran out of steam. As I finally lay down to sleep I could hear the celebrations still going on outside. It was the best lullaby ever.

THE NEXT MORNING I WAS surprised at how quickly life seemed to return to normal. As I walked around the city I half-expected to see people spontaneously freaking out with continued euphoria. But this did not happen. On the subway no one was howling with joy. Things looked the same as they had before Obama was elected. I wondered how everyone could be so restrained at this unique moment in history. Did they not realise that a black man had won the election?

Many so-called experts had said that it wasn't possible — that America was not ready for an African American president; that white people wouldn't vote for a black man; a man with a funny-sounding name, a man whose middle name is Hussein, and who actually has Muslim relatives; and that even if they did, he would be assassinated before he saw out his first term. In the end none of it happened.

I rang my mother back in London, not to talk about America's new president, but to check on her health, as she had just been to the dentist for some major reconstructive work. But all she wanted to talk about was Obama, America's new black king. I'd never really spoken to her about politics until that moment, and suddenly I felt closer to her, excited that there were still fresh things to discover about a woman I had known all my life.

The weekend following the election I read an article in *The New York Times* by a gay African American New Yorker, who contended that Obama's win had changed the perceptions of local white gays towards him. They were less wary of him as a result, and more curious. People who had previously ignored him now went out of their way to engage with him. I

wondered if this was happening in other places in America — if groups of whites that didn't usually engage with minorities were suddenly being more open as a result of Obama's victory. Could one man actually do this? Change race relations? The last time anything like it happened was in South Africa in the 1990s, when Nelson Mandela was released from prison and subsequently elected president.

The other thing that happened, post-election, was that people went out and bought newspapers — in their droves. Obama's win had provided publishers nationwide with a temporary boost to their flagging sales. *The New York Times* printed an extra 250,000 units to meet the demand for what was now a souvenir edition. Copies later popped up on eBay for $200 each. *The Washington Post* printed 30,000 extra copies, then an additional 250,000, followed by another 350,000. Meanwhile, at the offices of the *LA Times*, a line of eager customers stretched around the block as they printed an additional 100,000 copies.

The trajectory of Obama's popularity within magazine publishing was sensational. His appeal as a cover model peaked during his 2008 presidential campaign, as magazines that featured him on their front pages routinely sold out across the country. He was their new rock star — one with a certain old school charisma — like a cross between Marvin Gaye and Al Green. Obama single-handedly shored up sales in a year in which traditional celebrities waned in their page-one pulling power. In the American Society of Magazine Editor's annual poll of the best covers of 2008, Obama featured on no less than four of the covers of the finalists. There has never been a president in history that has straddled such a diversity of titles, from political and literary journals to hip-hop monthlies and comic books. Taken together they presented Obama's image in a myriad of guises — as deep thinker, messiah, superhero, model and sex symbol.

Barack Obama's popularity also caused ripples outside America. In November 2008 popular Iranian news weekly, *Shahrvand-e-Emrooz* (*Today's Citizen*), ran into trouble with the government when it featured the president-elect on its front cover, posing the question, "Why doesn't Iran have an Obama?" President Mahmoud Ahmadinejad, incensed by the headline, promptly shut the magazine down.

By the end of the momentous journey that had yielded the first African American president, I felt compelled to write a book about Barack Obama. I had to be one of the writers who said something about him to mark this historical moment. I wanted to belong to that group, as someone who was there, as a historian, as a black man, and as a citizen of the world that he then resided over. In my first book, *Black Beauty*, I talked about historical perceptions of the black image within European culture, and so the election of the world's first African American president, and the use of his face on the covers of magazines and newspapers, seemed a fitting point to begin another narrative.

Obama: 101 Best Covers is intended as a celebratory souvenir for all those who have followed his meteoric rise, and perhaps missed out on getting a copy of that certain commemorative publication first time around. Eight years in the making, this book aggregates the best of his covers, which have been selected from thousands of examples from around the world. The narrative compares and contrasts their different styles of photography, art direction and typography. The entries have been chosen to reflect as much creative diversity as possible. Many that did not make the shortlist used the same images or layout style as others, and so the single best examples have been selected in each case.

Since I first wrote this account back in 2008 Barack Obama has survived two terms in office, and has now reached that position when historians and commentators are busy assessing his legacy. Whatever one thinks of his many successes and failures as president, his reign is significant as a symbol of what is achievable in this cynical world. If a black man can rise against the odds to become president of the United States, then we collectively have no excuses for not achieving our own goals.

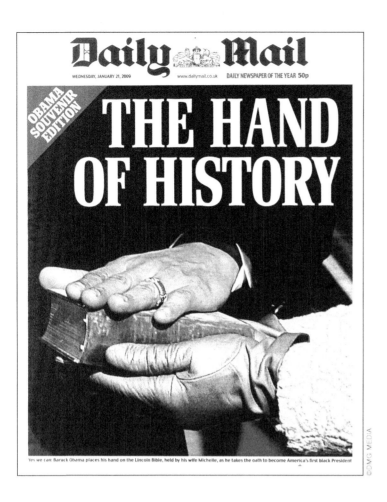

Daily Mail

WEDNESDAY, JANUARY 21, 2009 www.dailymail.co.uk DAILY NEWSPAPER OF THE YEAR 50p

OBAMA SOUVENIR EDITION

THE HAND OF HISTORY

Yes we can: Barack Obama places his hand on the Lincoln Bible, held by his wife Michelle, as he takes the oath to become America's first black President

TIME, FEBRUARY 2, 2009
THE DAILY MAIL, JANUARY 21, 2009

Time magazine's 2009 inaugural edition (published two weeks after the event) features what is possibly the most powerful image in American history — the moment many thought would never come — the inauguration of Barack Obama as the 44th President of the United States of America. At the time of the inauguration for the country's very first President, George Washington, on April 30, 1789, blacks were slaves. Suddenly, only 220 years later, on January 20, 2009, here was an African American president. It was a fairytale come true, and this image marks the dramatic, startling moment when the dream finally became reality. The occasion, crackling with pent-up emotion and drama, proved too much for many onlookers, who broke down in tears.

The picture, captured by *Time* photographer Christopher Morris, shows Obama with his left hand on the Lincoln Bible — the same revered tome used by President Abraham Lincoln at his 1861 inauguration. The 1,280-page volume is held by his wife Michelle, who looks on proudly as her husband takes the Oath of Office. Photographically there are many angles on this most supercharged moment, captured by a variety of photographers present on the day, and from a multitude of vantage points. It was the most popular image used on the covers of the world's newspapers and magazine weeklies the next day.

The cover of the UK's *The Daily Mail* illustrates the same moment, albeit from a closer perspective, zooming in on Obama's palm placed upon the Lincoln Bible, held by Michelle's gloved hand. The symbolism says as much about their relationship as husband and wife — with Michelle's hand supporting his — as it does about the politics of the event.

It was this formal moment when Barack Obama was sworn into office, and not his subsequent presidency, that defined him at his most powerful. The reality of an African American breaking through the country's racial barrier to become president, made the millions watching around the world realise that change was actually possible, both within politics and ultimately, within ourselves. This is Obama's real legacy.

COMMEMORATIVE ISSUE

TIME

PRESIDENT BARACK OBAMA
JANUARY 20, 2009

While the *Time* cover of Obama's inauguration records the dramatic moment that he finally became president, this image from *The Nation* reveals the history leading up to that moment. The February 2009 cover of the political journal, created by San Francisco-based artist and designer John Mavroudis, is one of the most original of Obama's reign. It took six months to plan and three months to draw. The highly emotive illustration — which perhaps takes it cue from the cover of The Beatles 1967 *Sgt. Pepper* album — depicts a newly elected Barack Obama being sworn into office, in the company of an intimate gathering of revered civil rights figures from history, whose achievements and sacrifices paved the way for his dramatic arrival as America's first African American president. Amongst those featured are Dr. Martin Luther King Jr., Nelson Mandela, Malcolm X, Mahatma Gandhi, Rosa Parks, Jesse Jackson, Thurgood Marshall, Abraham Lincoln and Steve Biko. They witness the historic scene from the packed pews, shocked, stunned and proud that the day many thought would never come has actually arrived.

But even with this interstellar audience, Mavroudis was acutely aware of the civil rights champions he'd left out of the frame. "There's not enough pages to accommodate everyone who has helped bring about this wonderful moment," he said at the time. The cover itself was a risky venture for him and the magazine's editors, because when it was commissioned it was far from certain that Obama would win, and all of Mavroudis's artwork could have gone to waste. As it turned out, all ended well, and the artwork became one of the most talked about covers of the year.

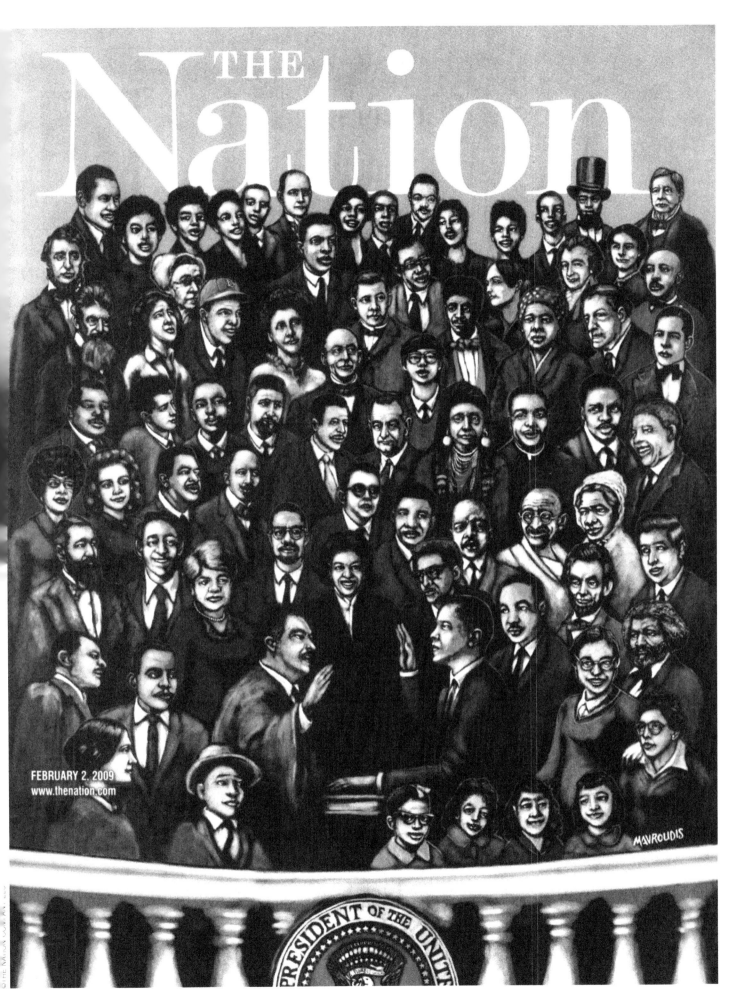

THE Nation

FEBRUARY 2, 2009
www.thenation.com

MAVROUDIS

The Teleg

48 PAGES CALCUTTA WEDNESDAY 21 JANUARY 2009

CHANGE I:

44th BUT FIRST

Years later, if your children and grandchildren ask you what the big deal was on January 20, 2009, show them this armada of the most powerful men of their time.

Forty-three occupied the Oval Office with a common thread called race stringing together two centuries and 19 years. Then stepped in the 44th, Barack Obama, who stands out in more ways than one

George Washington
1789-97

John Adams
1797-1801

Thomas Jefferson
1801-09

James Madison
1809-17

James Monroe
1817-25

John Quincy Adams
1825-29

Andrew Jackson
1829-37

Martin Van Buren
1837-41

Abraham Lincoln
1861-65

Andrew Johnson
1865-69

Ulysses S. Grant
1869-77

Rutherford B. Hayes
1877-81

James A. Garfield
1881-81

Chester A. Arthur
1881-85

Grover Cleveland
1885-89

Benjamin Harrison
1889-93

Herbert Hoover
1929-33

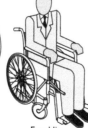
Franklin. D. Roosevelt
1933-45

Harry S. Truman
1945-53

Dwight D. Eisenhower
1953-61

John F. Kennedy
1961-63

Lyndon B. Johnson
1963-69

Richard Nixon
1969-74

Geral Ford
1974-7

ON SPECIAL ★★★★★

aph

CE www.telegraphindia.com

HERE

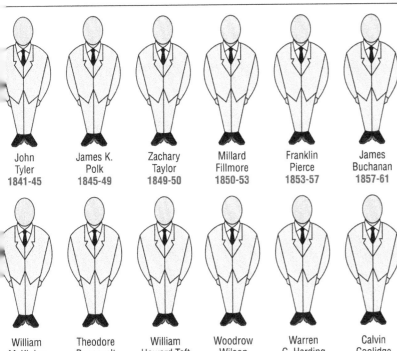

| John Tyler 1841-45 | James K. Polk 1845-49 | Zachary Taylor 1849-50 | Millard Fillmore 1850-53 | Franklin Pierce 1853-57 | James Buchanan 1857-61 |

| William McKinley 1897-1901 | Theodore Roosevelt 1901-09 | William Howard Taft 1909-13 | Woodrow Wilson 1913-21 | Warren G. Harding 1921-23 | Calvin Coolidge 1923-29 |

 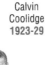

| Ronald Reagan 1981-89 | George H.W. Bush 1989-93 | Bill Clinton 1993-2001 | George W. Bush 2001-09 | Barack Obama January 20, 2009- |

THE TELEGRAPH (INDIA),
JANUARY 21, 2009

The Telegraph India adopted this original approach to the election of America's first African American president. Their illustration renders the previous 43 American presidents as a regimented array of identikit faceless white men, all cut from the same mould, with Obama dramatically positioned at the end of the sequence — the sudden shocking change after centuries of mono-ethnicity. "44th But First" declares the header to the left of the picture.

This Obama cover uses someone else's face in celebration of his 2008 presidential election victory. It features a picture of Grace Isabella Mills, an "Obama baby", born in New York during election year, on November 4, 2008. She is photographed wearing a t-shirt bearing the new president's name, and with a victorious fist thrust up in the air defiantly, like the black nationalists of the 1960s, or Nelson Mandela in his prime.

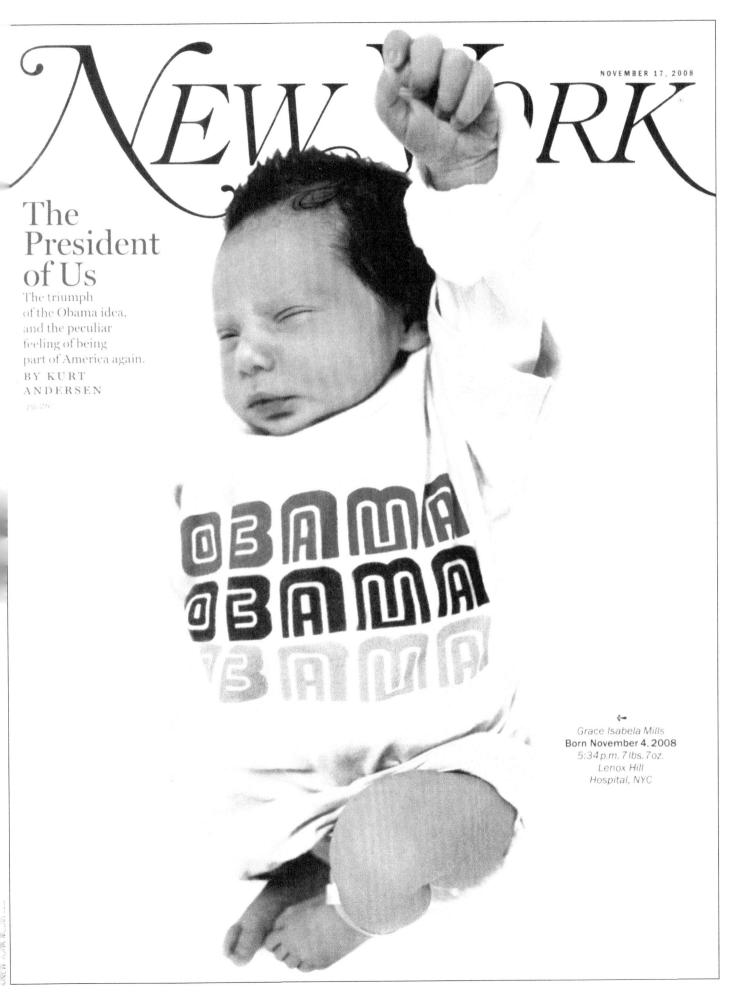

NEW YORK

The President of Us

The triumph of the Obama idea, and the peculiar feeling of being part of America again.

BY KURT ANDERSEN

(pg. 26)

OBAMA
OBAMA
OBAMA

←
Grace Isabela Mills
Born November 4, 2008
5:34 p.m. 7 lbs. 7 oz.
Lenox Hill
Hospital, NYC

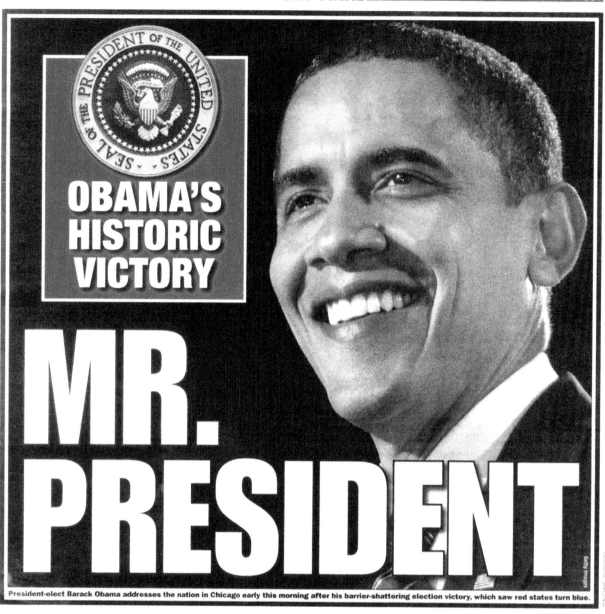

NEW YORK POST, NOVEMBER 5, 2008
THE CITIZENS' VOICE, NOVEMBER 5, 2008

The *New York Post*'s front page of November 5, 2008 illustrates the simple, impactful directness characteristic of tabloid newspaper design. It incorporates just three powerful elements — The Seal of the Presidency, a large smiling headshot of the victor, and two simple words of exposition — "Mr President".

By contrast, the power of *The Citizens' Voice* cover from the same day lies within the crowd of euphoric faces in the background of the photograph, which overpower the presence of the new president and his wife. All of America's ethnic melting pot is represented here on election night 2008, smiling excitedly like teenagers at a rock concert, waving flags and taking photographs, happily penned in behind bulletproof glass after waiting patiently on their feet for hours to bear witness to this most dramatic moment. The elated expressions on their faces illustrate exactly how much Obama's election meant to them, and to so many others.

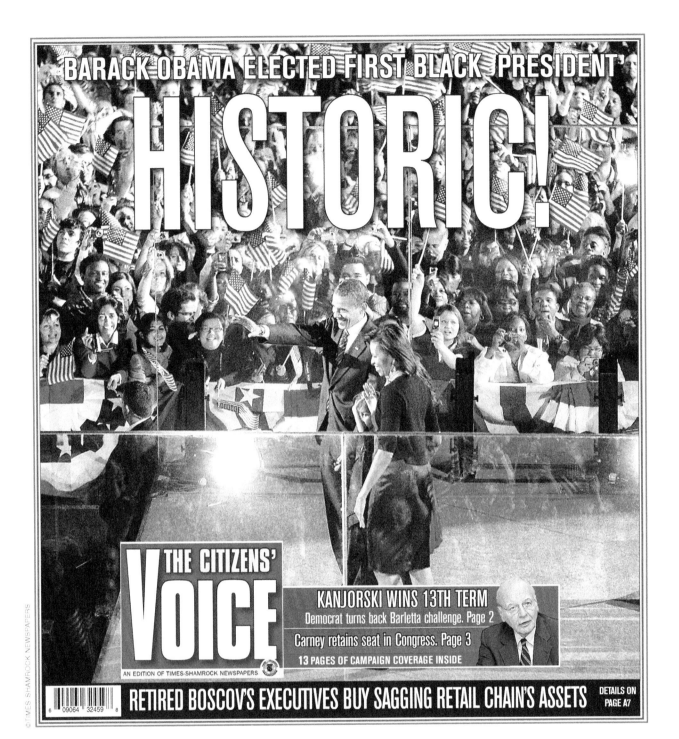

BARACK OBAMA ELECTED FIRST BLACK PRESIDENT

HISTORIC!

THE CITIZENS' **VOICE**

AN EDITION OF TIMES-SHAMROCK NEWSPAPERS

KANJORSKI WINS 13TH TERM
Democrat turns back Barletta challenge. Page 2
Carney retains seat in Congress. Page 3
13 PAGES OF CAMPAIGN COVERAGE INSIDE

6 09064 32459 8

RETIRED BOSCOV'S EXECUTIVES BUY SAGGING RETAIL CHAIN'S ASSETS

DETAILS ON PAGE A7

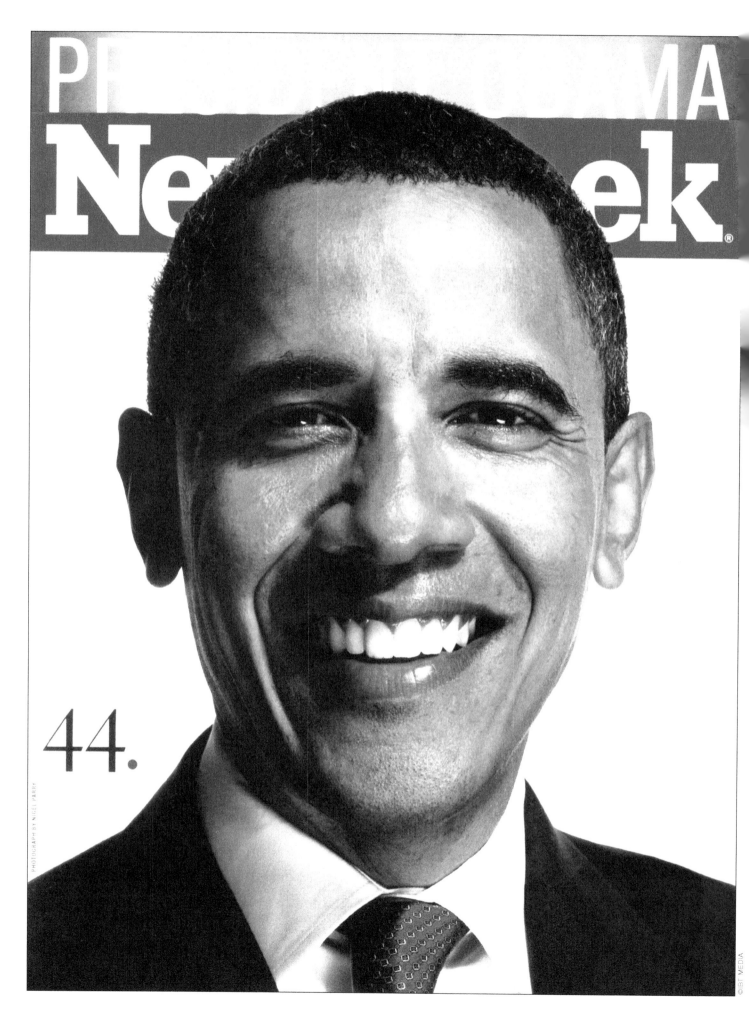

44.

Tim
Chi

JANUARY 15–21, 2009
ISSUE NO. 203 $2.99
TIMEOUTCHICAGO.COM

OBAMA

44

BE LIKE
BARACK!

+

SEVEN
GREAT
BURGERS

SUN-
SOAKED
LOCAL
RETREATS

BID
ON THIS
JERSEY!

←

These executions make use of the number 44 (Obama was America's 44th president) to mark his 2008 election victory. The cover of *Time Out* (Chicago) would no doubt have resonated with the president, as basketball is his favourite sport. The magazine opted for powerful simplicity in creating a basketball jersey hanging in a locker room adorned with the new president's name, plus the special number.

Newsweek used the same double digits, but this time completed with a full stop, punctuating the simple fact of Obama's historic win. The photograph, by Nigel Parry, displays the winning smile of the victor, who stares straight at us, inviting us all to feel what he is feeling.

MEN'S JOURNAL, MARCH 2009

Following on from *Time Out* Chicago's basketball-themed cover came this sporting edition from men's fitness and lifestyle title, *Men's Journal*. Their treatment, high on patriotism, focuses on the president's love of American sports, complete with the Stars and Stripes in the background. Barack Obama glances off to the side of the frame, beyond the confines of the magazine, as if he is about to throw the football to someone over yonder. The cover transcends a history that once stereotyped a black man as a sports star or a musician, but never a president.

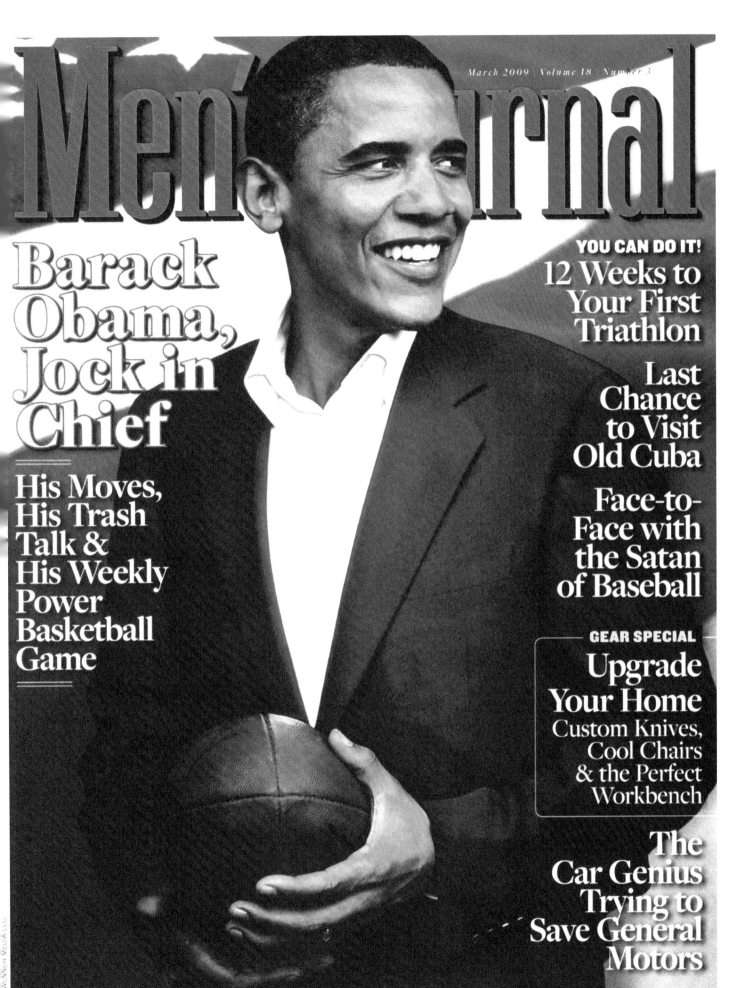

March 2009 Volume 18 Number 3

Men's Journal

Barack Obama, Jock in Chief

His Moves, His Trash Talk & His Weekly Power Basketball Game

YOU CAN DO IT!
12 Weeks to Your First Triathlon

Last Chance to Visit Old Cuba

Face-to-Face with the Satan of Baseball

GEAR SPECIAL
Upgrade Your Home
Custom Knives, Cool Chairs & the Perfect Workbench

The Car Genius Trying to Save General Motors

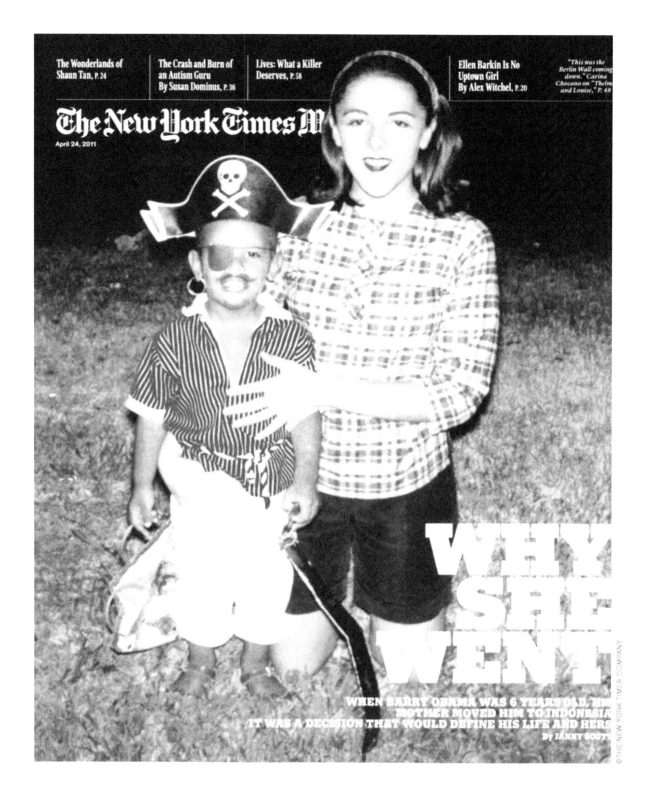

Inside the image (magazine cover text):

The Wonderlands of Shaun Tan, P. 24

The Crash and Burn of an Autism Guru By Susan Dominus, P. 36

Lives: What a Killer Deserves, P. 58

Ellen Barkin Is No Uptown Girl By Alex Witchel, P. 20

"This was the Berlin Wall coming down." Carina Chocano on "Thelma and Louise," P. 48

The New York Times M

April 24, 2011

WHY SHE WENT

WHEN BARRY OBAMA WAS 6 YEARS OLD, HIS MOTHER MOVED HIM TO INDONESIA. IT WAS A DECISION THAT WOULD DEFINE HIS LIFE AND HERS. By JANNY SCOTT

© THE NEW YORK TIMES COMPANY

NEW YORK TIMES MAGAZINE, APRIL 24, 2011
TIME, APRIL 21, 2008

This is where it all began. These covers, published three years apart from one another, tap into powerful emotions about family, and about a single mother and her son. In both photographs Barack Obama's late mother Ann Dunham's love for her child is conveyed through her hands, which are wrapped affectionately around his body. Although taken at different times in their lives, the images possess emotionally identical sentiments between Obama and the woman he described as, "the dominant figure in my formative years." Obama's rise to the White House seems even more startling when viewed through the prism of these photographs. How could this unassuming little African American boy, dressed in a pirate's outfit, rise to become the most powerful man in the world?

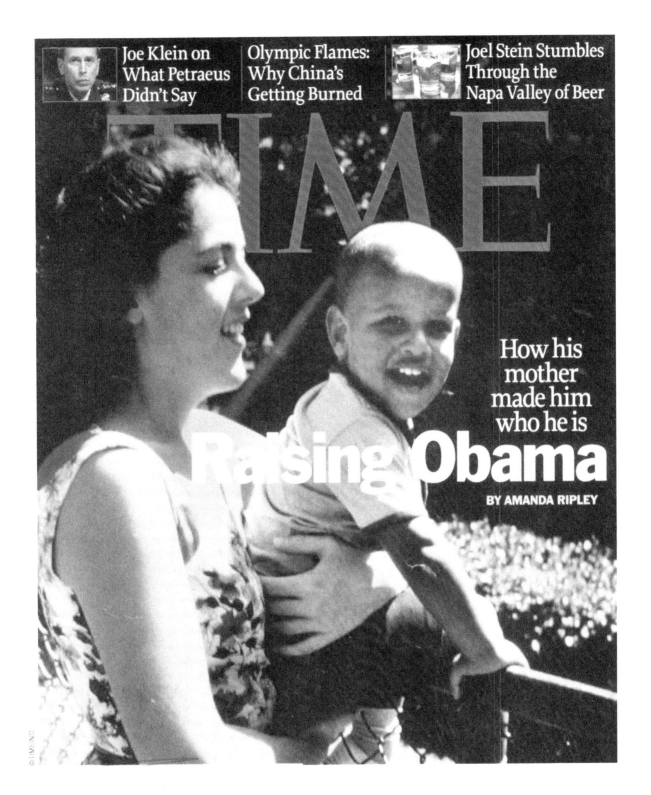

Joe Klein on
What Petraeus
Didn't Say

Olympic Flames:
Why China's
Getting Burned

Joel Stein Stumbles
Through the
Napa Valley of Beer

TIME

How his
mother
made him
who he is

Raising Obama

BY AMANDA RIPLEY

©TIME INC

In the run up to the 2008 presidential election, the news-weeklies ran a number of stories about Obama's formative years, illustrating them with images of the president when he was young. *Newsweek's* stark rendering uses a white page illustrated with a low-quality passport-sized photo of the senator in his early twenties, complete with mini-afro. The headline, "When 'Barry' Became Barack" introduces a lead story about the period when Obama began using his real first name instead of "Barry", as part of his efforts to reconnect with his identity.

Newsweek

When 'Barry' Became Barack

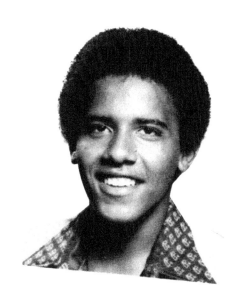

PHOTOGRAPH COURTESY OF OCCIDENTAL COLLEGE $4.95 US

MARCH 31, 2008

newsweek.com

Obama's 1979 Occidental College application photo

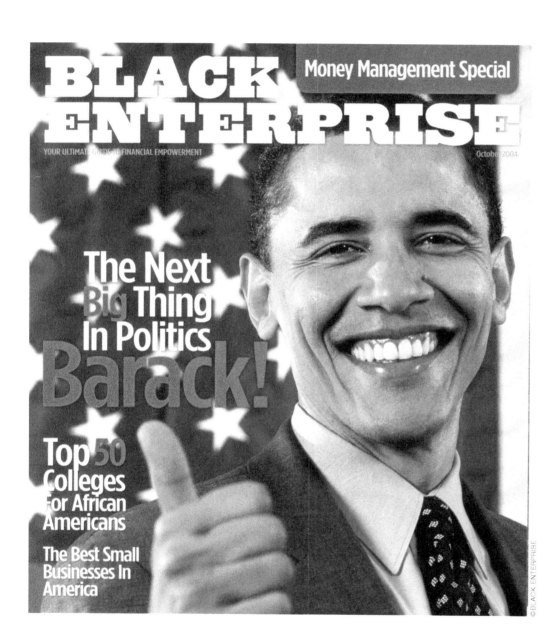

This is Barack Obama's first ever magazine cover. African American business title *Black Enterprise* got there ahead of the mainstream news and politics titles, featuring the young statesman four years before he was first elected president. Obama visited the magazine's offices in early 2003 when he was a state legislator at the Illinois Senate. But when he told the magazine's editors of his ambitious plans to run for the United States Senate they were initially sceptical. Did he really have the ability, the backing and the funds to achieve this milestone? Was he being realistic about just how far a black man could go in modern American politics?

After an extensive Q&A session Obama won them over with his drive and ambition. Managing editor Kenneth Meeks was so taken by the young politician that he decided to shadow him on the campaign trail for the Senate seat, where Obama continued to impress — so much so that the magazine decided to put him on the cover of their October 2004 edition, tipping him to become "The Next Big Thing in Politics". Signed copies of this historic edition have since become highly collectable. In March 2009 one was sold on eBay for $1,600. This cover would go on to become the first of thousands to feature the country's first African American president. Soon his face would be the most famous on Earth. The rest, as they say, is history.

SPECIAL DOUBLE EDITION

Newsweek

Keep on sale until January 3, 2005

newsweek.msnbc.com

2005
Barack Obama

A Rising Star
Who Wants to
Get Beyond
Blue vs. Red

Seeing Purple

PLUS

Politics: Rick Santorum
Business: Andrea Jung
Fashion: Thom Browne
Movies: Michelle Monaghan
Sports: Donald Young
... And **More**

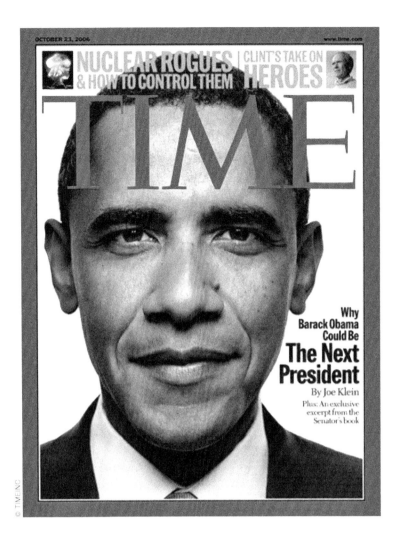

NUCLEAR ROGUES & HOW TO CONTROL THEM | CLINT'S TAKE ON HEROES

TIME

Why
Barack Obama
Could Be
**The Next
President**
By Joe Klein

Plus: An exclusive
excerpt from the
Senator's book

© TIMEINC

NEWSWEEK, DECEMBER/JANUARY 2005
TIME, OCTOBER 23, 2006

Newsweek was second to feature the Senator, in December of the same year, beating arch-rival *Time* to the punch — who would not feature him on its front page until October 2006. This special year-end double issue shows a youthful president-to-be set against a shimmering silver background. He was profiled in the magazine's annual "Who's Next" feature on the new generation of rising stars.

In October 2006, when *Time* first featured Barack Obama on its cover, it went on to become the magazine's second best-selling issue of that year. It coincided with the release of the senator's second book, *The Audacity of Hope*, which was excerpted inside. In this featured cover he stares straight at us with a confident and focused determination, his face filling the whole frame, which is contained by *Time*'s trademark red border. Unlike *Newsweek*'s cover, *Time*'s went further in predicting that the senator could be "The Next President". It marked the moment when the magazine finally got hot for the newcomer. In the euphoria surrounding Obama's rise these early covers rapidly became collectable. In January 2009 a copy of this edition, signed by the senator, sold on Amazon for $1,200.

But was "Obama-mania" getting out of control? As Election Day 2008 approached, and cover after cover featuring the presidential hopeful hit newsstands everywhere, commentators began asking if the media, and the news-weeklies in particular, were biased towards Obama. On June 30th Mark Hemingway, writing for the *National Review*, dubbed *Newsweek* "Obamaweek" for its relentless coverage of the Democratic candidate's campaign. *Time* was accused of bias after featuring Obama on its cover an incredible 23 times during his presidential campaign, while Republican challenger John McCain appeared only 10 times during the same period. "*Time* magazine has once again placed the 'Obamessiah' on its cover," quipped the website, NewsBusters, the media watchdog devoted to challenging liberal bias in the media. Meanwhile, the editors of *Slate* magazine coined the term, "Baracksploitation", to describe the excessive coverage of the presidential hopeful. The debate culminated in a July survey by Rasmussen Reports that found that 49 per cent of voters believed that most reporters were trying to help Obama, while just 14 per cent believed that they were trying to help Senator McCain.

Obama: 101 Best Covers 33

ROLLING STONE, JULY 10, 2008

As "Obama-mania" intensified in the run up to the 2008 election, accusations of bias toward the Democratic candidate continued. Jeff Bercovici, writing in *Portfolio*, stated that publishing mogul Jann Wenner, an Obama-supporter, had a "crush" on the senator, after he appeared on the cover of *Rolling Stone*, one of Wenner's titles, three times in 2008, as well as on the front of sister title *US Weekly* in the same year.

This edition of *Rolling Stone*, from July of that year, epitomised what a hot publishing property Obama had become during election year. A copy of this edition, signed by the senator at a campaign rally in Detroit, Michigan, sold on eBay for $1,400, before he'd even won the election. Voted number three in *Time's* top 10 magazine covers of 2008, the graphic power of the composition is conveyed not simply by the style of photography — with Obama glancing down smiling, almost shyly, his head angled toward the badge of the American flag on his lapel — but also by the sparse simplicity of a design free of cover lines. The playful, unguarded informality of the image — shot by Peter Yang in Raleigh, North Carolina, just days after Obama secured the Democratic nomination — draws the reader into the magazine by implying that this profile will show us another, more personal side to the presidential candidate than those of the news-weeklies. The photograph — snapped in a split second as Obama reacted to something said off camera — breaks with magazine-cover convention in not having the eyes of the subject fixed toward the lens. The absence of cover lines marked the moment in which Obama's fame transcended the cover typography normally needed to sell magazines. He is in special company here, as there are but a few stars whose image remains so potent as to need no written accompaniment — Marilyn Monroe, Michael Jackson, Lady Diana and Elvis all spring to mind — but Obama was the first such star of the new century.

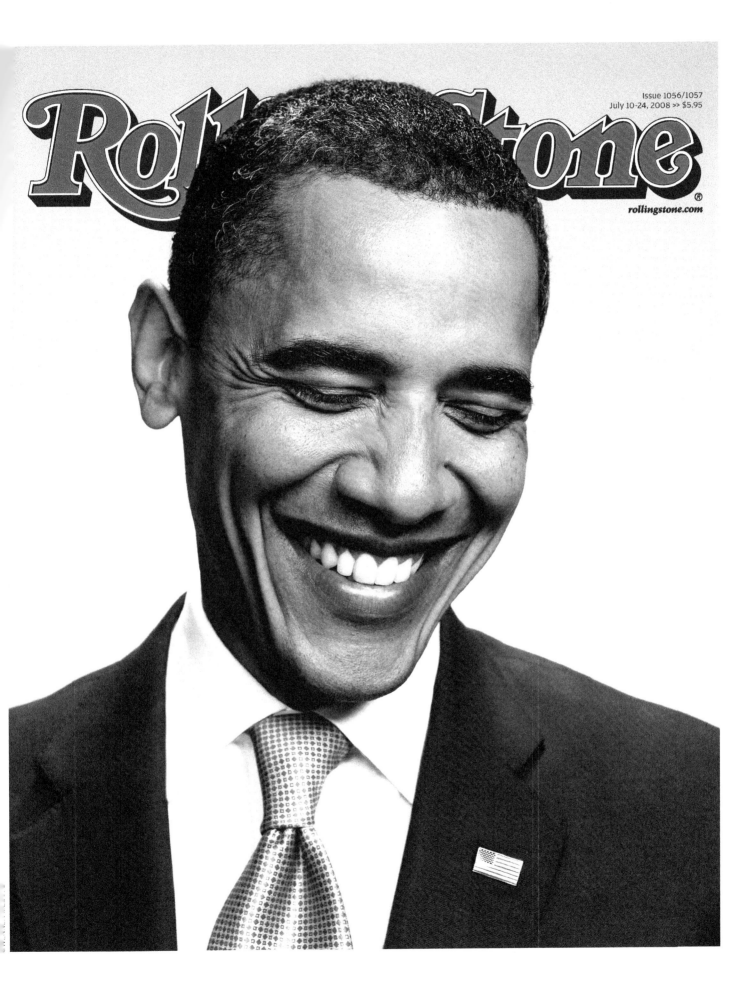

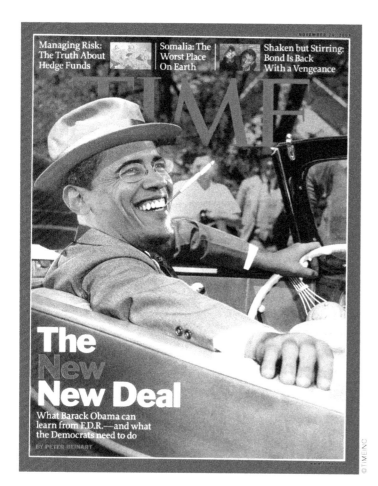

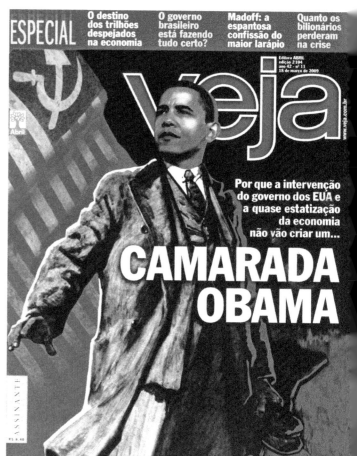

TIME, NOVEMBER 24, 2008
VEJA, MARCH 18, 2009
THE NEW YORKER, JANUARY 26, 2009

Could one man really represent all this? These covers present President Barack Obama as three well-known historical figures. *Time* depicts him as Franklin D. Roosevelt, *The New Yorker* renders him as George Washington, while Brazilian news journal *Veja* opts for Russian communist revolutionary Vladimir Lenin. Collectively they illustrate the breadth of opinion, if not outright confusion, about exactly what the new president stood for in the months right after he was first elected. All three covers are of their time in that they relied on the politics of symbolism in place of the facts. But now that we have the facts about Obama's reign, and therefore the benefit of hindsight, these depictions, though humorous, seem wildly inaccurate, if not ridiculous.

PRICE $4.99

THE
NEW YORKER

JAN. 26, 2009

Senator Barack Obama was amongst a select group of 21 celebrities chosen for *Vanity Fair's* special Africa edition of 2007. Others included Muhammad Ali, Maya Angelou, Bono, George W. Bush, George Clooney, Bill Gates, Jay-Z, Madonna, Oprah, Brad Pitt and Bishop Desmond Tutu. Photographer Annie Leibovitz paired them up to create a unique set of 20 different covers. The edition — which quickly sold out after release — was guest edited by Bono on behalf of his Project RED organisation, dedicated to raising awareness and funds to eliminate HIV-AIDS in Africa. The covers were backed up inside with a special collection of stories about life across the continent. "As guest editor, I want Africa to appear as an adventure, not a burden, and to put faces and personalities to the statistics we read elsewhere," said Bono.

Obama — whose late father was Kenyan — appeared on two of the covers, together with the late ex-heavyweight boxing champion Muhammad Ali (right) and actor Don Cheadle. The senator was invited to take part at exactly the moment when the heat was rising fast on his presidential candidacy. But he was not yet a superstar. The covers were shot during March and April of 2007, over a year before Obama won the Democratic nomination. Within the cover featured here, Obama plays the supporting role to Ali, positioned behind the ex-boxer, and with his eyes to the floor. Had his image been shot after his 2008 election victory instead of before, the composition may well have been different.

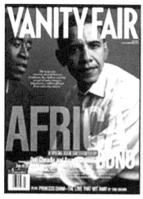
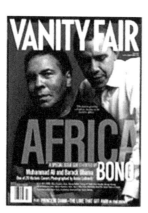

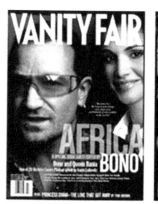
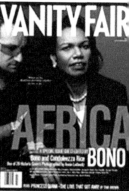
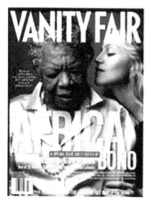
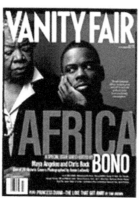
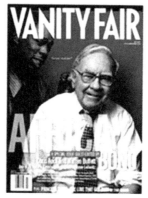
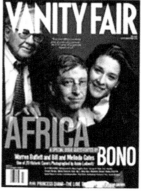
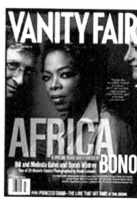

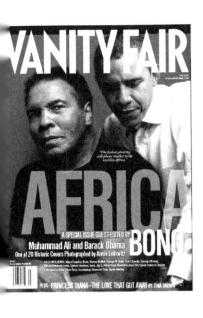

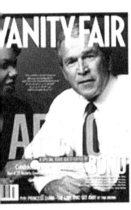
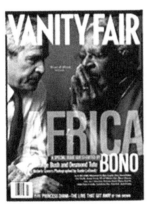
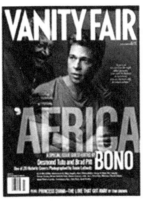
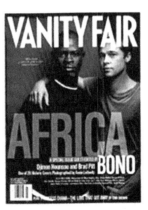
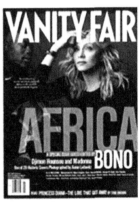

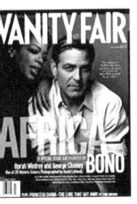
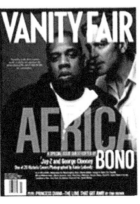
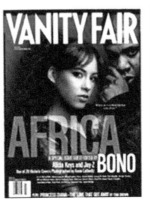
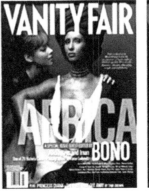
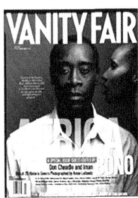

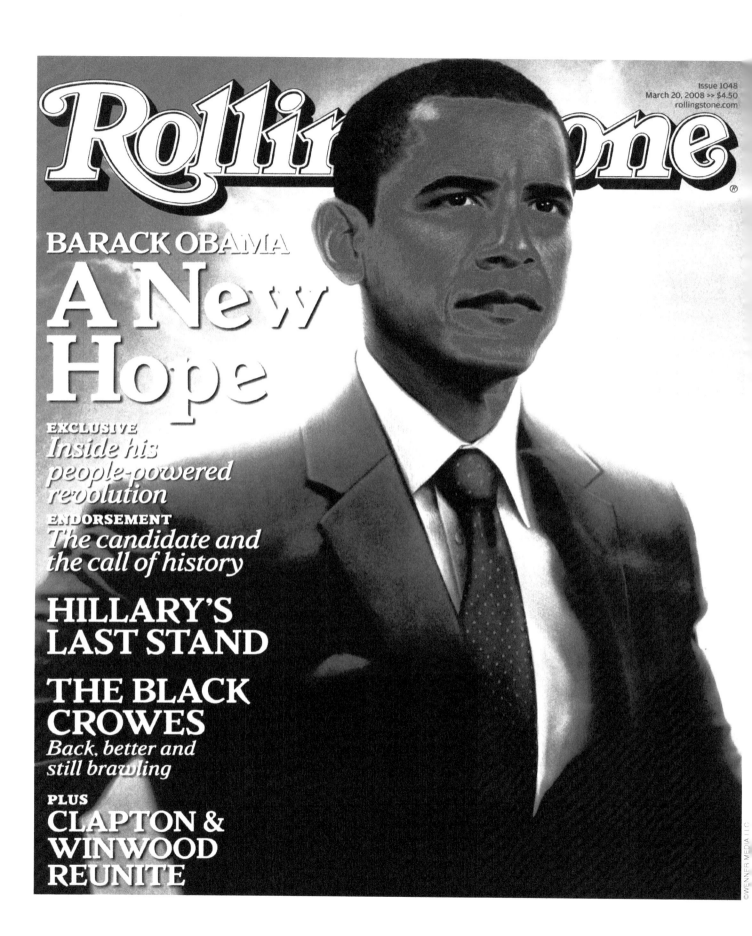

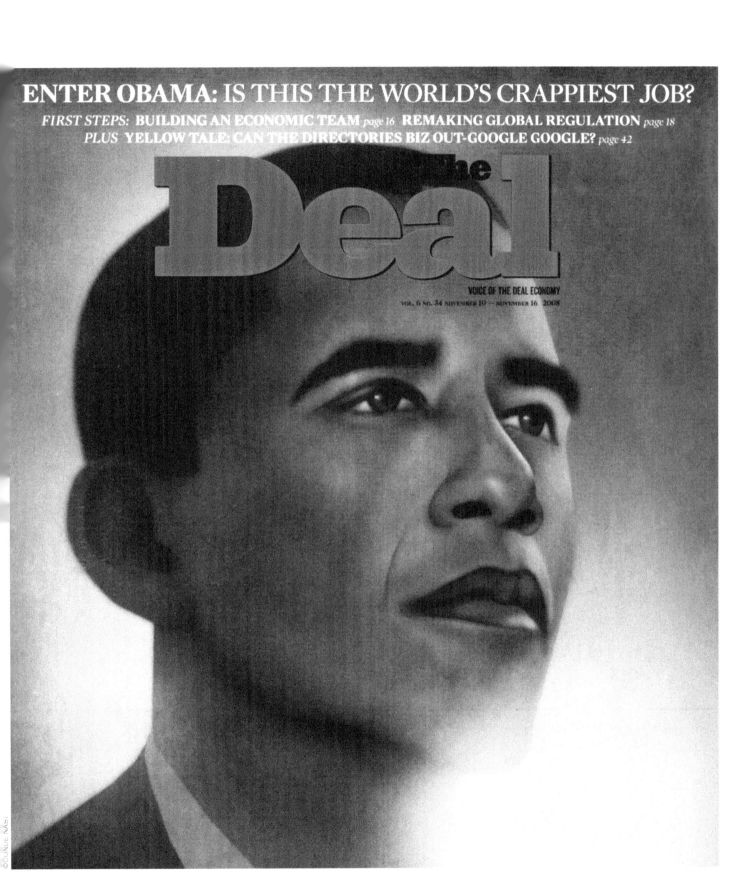

ENTER OBAMA: IS THIS THE WORLD'S CRAPPIEST JOB?

FIRST STEPS: **BUILDING AN ECONOMIC TEAM** *page 16* **REMAKING GLOBAL REGULATION** *page 18*

PLUS **YELLOW TALE: CAN THE DIRECTORIES BIZ OUT-GOOGLE GOOGLE?** *page 42*

The Deal

VOICE OF THE DEAL ECONOMY

VOL. 6 NO. 34 NOVEMBER 10 — NOVEMBER 16 2008

These covers illustrate the potency of the Obamessiah effect within popular magazines. In the run up to Election Day 2008 Obama seemed to live up to the lofty expectations thrust upon him, with a flawless campaign that lead many magazines to exalt him as the nation's saviour. *Rolling Stone*'s first Obama cover features an image by illustrator Tim O'Brien of the Democratic candidate against a heavenly blue sky, together with an angelic white halo-effect dusted around his head and shoulders. The edition was their biggest seller of the year.

Business magazine *The Deal* used a similar graphic technique as the background to its youthful portrait of the would-be president. This time a hopeful yellow glow, a rising sun behind his head, conjured a metaphor of a new day of change, lead by the young statesman.

THE NEW REPUBLIC, JANUARY 30, 2008

The cover of *The New Republic*'s January 30, 2008 edition presents a more overtly religious rendering in which painter and performance artist Cynthia von Buhler portrays Obama as a Christ-like figure within a stained glass window, complete with the American flag washing through him and a Virgin Mary-style halo around his head. The air of sainthood is intensified by the red curtain that frames the edge, giving the impression that the artwork has just been unveiled in church.

The New
REPUBLIC

THE TRIALS OF BARACK OBAMA

JONATHAN COHN / MICHAEL CROWLEY / JEFFREY ROSEN / NOAM SCHEIBER / CASS R. SUNSTEIN / LEON WIESELTIER

THE
BIGOTRY
of RON PAUL
JAMES KIRCHICK

THE
SCANDAL
of IRÈNE
NÉMIROVSKY
RUTH FRANKLIN

THE
FUTILE
LONGING
of PHILIP
GLASS
DAVID HAJDU

JAN. 30, 2008
$4.95

12 October 2009/£2.95

www.newstatesman.com

16-page Books Special: What to read this autumn

Will Self Mehdi Hasan **Susan Greenfield** Mark Watson **John Gray**

NewStatesman

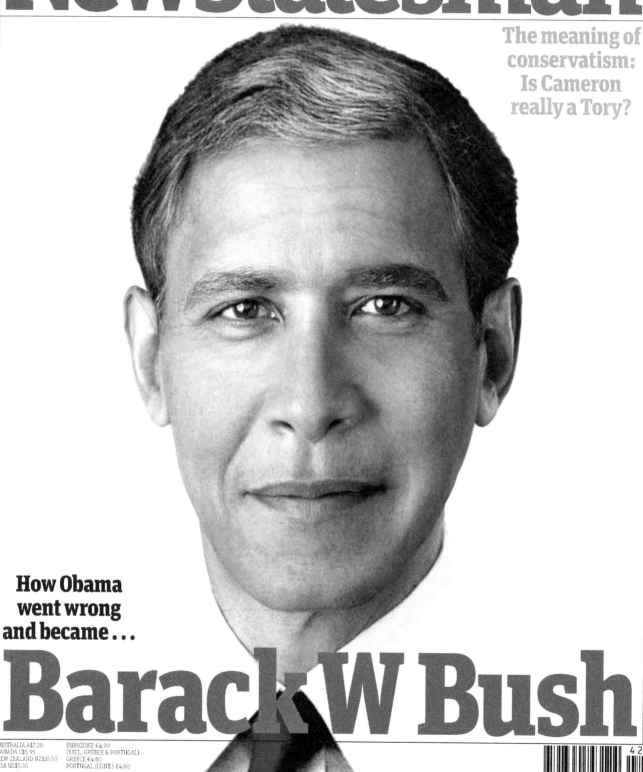

The meaning of
conservatism:
Is Cameron
really a Tory?

**How Obama
went wrong
and became . . .**

Barack W Bush

AUSTRALIA A$7.20
CANADA C$5.95
NEW ZEALAND NZ$10.50
USA US$5.50

EUROZONE €4.90
(EXCL. GREECE & PORTUGAL)
GREECE €4.60
PORTUGAL (CONT.) €4.90

9 771364 743124

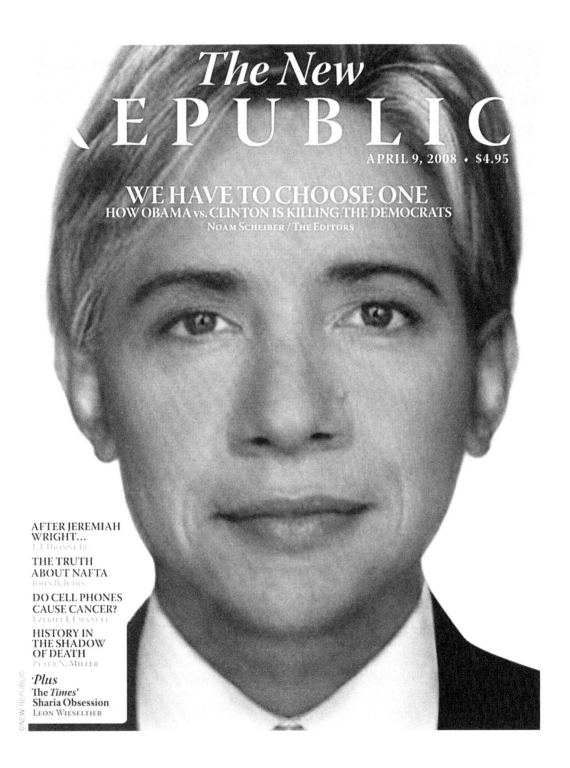

The New
REPUBLIC

APRIL 9, 2008 • $4.95

WE HAVE TO CHOOSE ONE
HOW OBAMA vs. CLINTON IS KILLING THE DEMOCRATS
Noam Scheiber / The Editors

AFTER JEREMIAH WRIGHT...
E.J. Dionne Jr.

THE TRUTH ABOUT NAFTA
John B. Judis

DO CELL PHONES CAUSE CANCER?
Ezekiel J. Emanuel

HISTORY IN THE SHADOW OF DEATH
Peter N. Miller

Plus
The *Times'*
Sharia Obsession
Leon Wieseltier

©NEW REPUBLIC

These are two of the best examples of Obama "face-melds". On the left is an execution from British left-wing political weekly, *The New Statesman*, which presents a fusion of the faces of Barack Obama and George W. Bush. The image — alongside the cover line, "Barack W Bush" — was conceived to illustrate the lead article by senior editor Mehdi Hasan, which contended that Obama's policies as president mirrored those of his Republican predecessor. The skilled artistry of the composition commands the attention. The ears are those of Bush, but the eyes are Obama's — although the finished face resembles someone of Middle-Eastern origin. This fictional persona could either be Obama's cousin or Bush's long-lost brother.

The March 2008 edition of politics and culture title, *The New Republic* provided one of the most striking covers of the Obama era. It was created by artist Nancy Burson — one of the pioneers of digital morphing technology and the brains behind the famous face-blending sequence in Michael Jackson's "Black Or White" video. In fact, her morphing software was so good that she sold it to the FBI for use in tracking down missing children by digitally ageing their portraits.

Christened "HillarACK" by its editors and "Hillbama" by bloggers who raved about it online, Burson's artwork for *The New Republic* features a fifty-fifty blend of the faces of Barack Obama and Hillary Clinton. "The discussion started with the idea that the Democrats seemed to want it both ways — hence the idea of morphing the two faces," recalled art director Joe Heroun. The image forms a striking blend of man and woman, of black and white, of Democrat and Democrat. The synthesis is serene, youthful and androgynous. The eyes look almost East Asian in appearance, while the mouth appears to be smiling slightly, like a modern-day Mona Lisa, almost as if this imaginary person knows something we don't. The cover line, "We Have To Choose One", runs across the forehead of the photographic mash-up, challenging the reader to decipher one from the other.

"We've had more media attention from this cover than any we've ever done," said Heroun at the time. "All the blogs were on fire." In the years since these two covers were released, a host of creative experiments in "digital genetics" have become commonplace, and the Internet is awash with bizarre variations of Obama face-melds.

This cover illustrates the face-off between Hillary Clinton and Barack Obama for the 2008 Democratic nomination for the president of the United States. Unlike the previous Obama face-melds, the design presents a hard dividing edge between the images of the two rivals — taken by photographers Callie Shell and Damon Winter. The creative was inspired by an advertisement for the NBA play-offs that were running concurrently, featuring the half-faces of various basketball stars. In this two-faced composition both Democratic candidates share the cover fifty-fifty, with Obama's steely gaze contrasting with Clinton's wide-eyed openness. The viewer has a double reading of the image both as a single, abstract Picasso-like composition, and as two separate halves. The uneasy juxtaposition highlights not only their opposition as would-be presidential candidates, but also the physical differences in their skin-tone, hair, facial features and styles of clothing. For the finishing touch, the cover line, "There can be only one" — from the 1986 movie, *Highlander* — is strapped across their noses like a Band Aid holding the two half-images together.

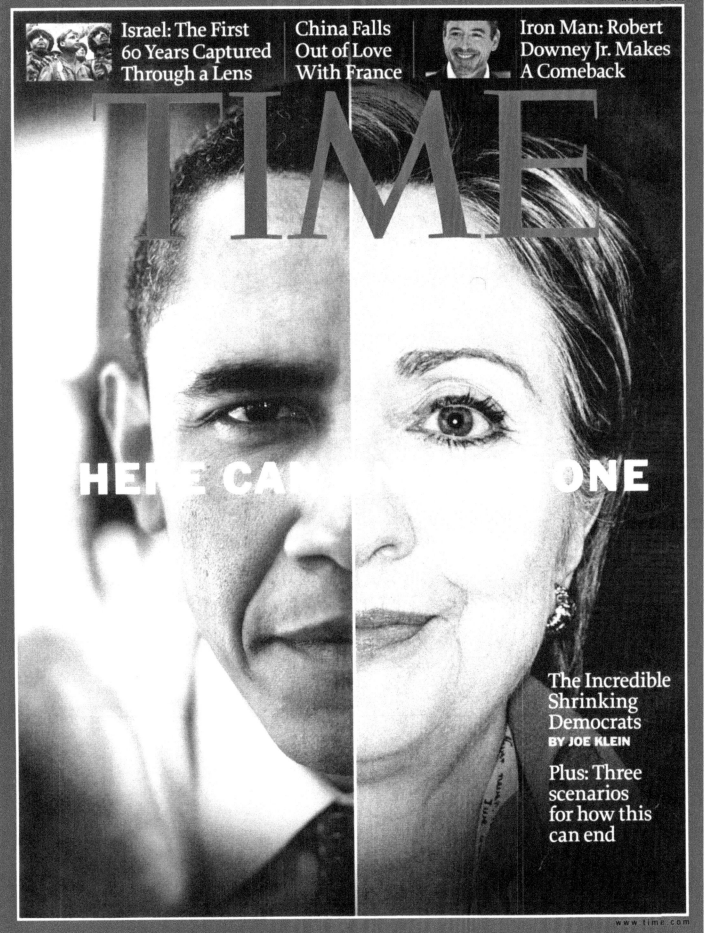

MAY 5, 2008

Israel: The First 60 Years Captured Through a Lens

China Falls Out of Love With France

Iron Man: Robert Downey Jr. Makes A Comeback

TIME

HERE CA... ONE

The Incredible Shrinking Democrats
BY JOE KLEIN

Plus: Three scenarios for how this can end

www.time.com

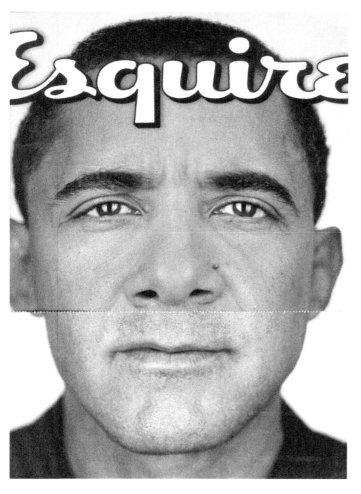

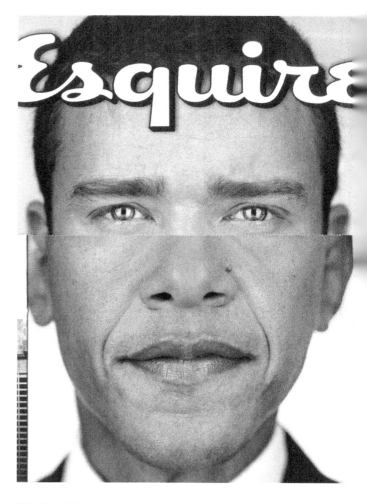

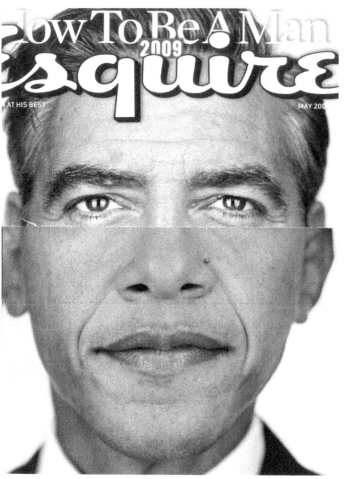

ESQUIRE, MAY 2009

Barack Obama did not actually feature on page one of *Esquire*'s 2009 "How To Be A Man" issue — that honour went to actor George Clooney. But the president, alongside singer Justin Timberlake, did feature on the early pages as part of the first ever "mix-n-match" magazine cover. *Esquire*'s design director David Curcurito and photographer Martin Schoeller came up with the idea of using three celebrity photos from Schoeller's well-known series of close-up portraits. Each page-sized face was laid on top of one another within the first few pages of the magazine, and then each of them were divided horizontally into three page-turnable strips, each of which contained sections of the eyes, nose or mouth of each person. Like a low-tech version of Snapchat's face swap app, by flicking through the sections and interchanging the features of the three stars, readers could compile their own mug-shot-style facial mash-ups, from 27 possible combinations. *Esquire*'s original attempt to "gamify" their cover meant that readers interacted with its pages more than they normally would.

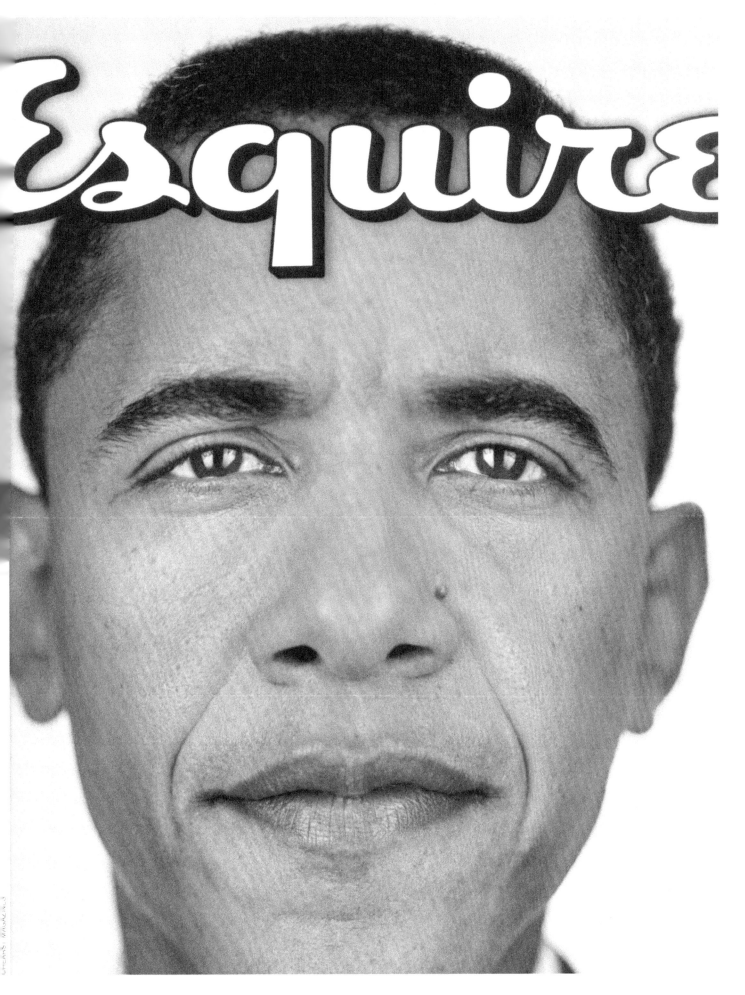

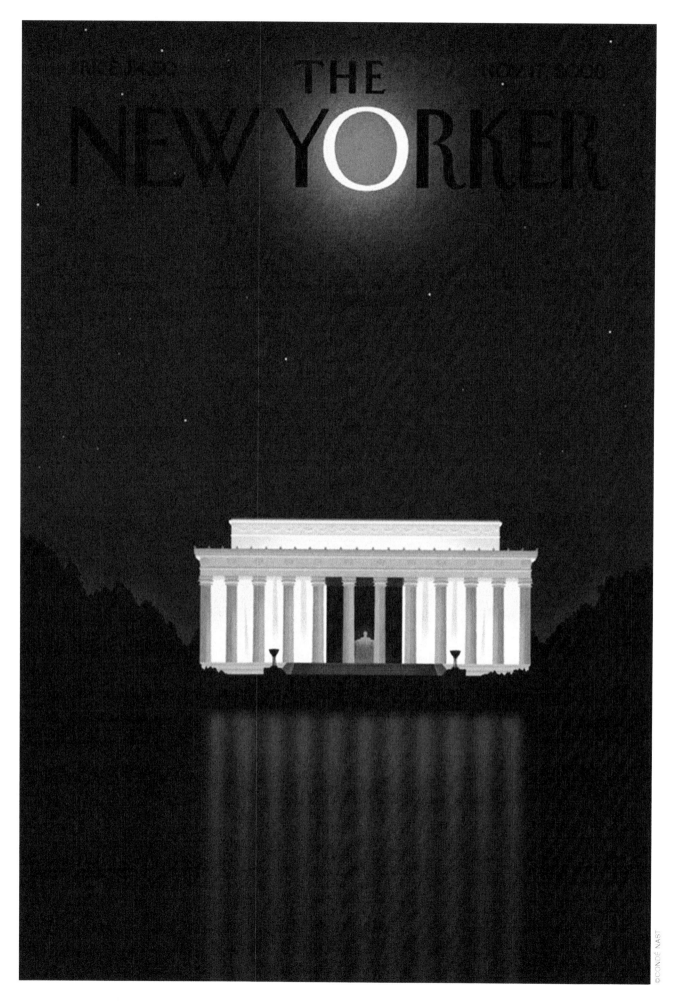

This edition of *The New Yorker* — voted magazine cover of that year by *Time* — ran soon after Obama's first election victory. The artwork, called *Reflection*, by illustrator Bob Staake, depicts a luminous hollowed out moon as the letter "O" within the magazine title's typography, casting the light of the president-elect down upon the elevation of the Lincoln Memorial. The design stands out in its quietude and understatedness amidst the bombast of other covers marking this historic moment. "I've been fortunate enough to do a number of *New Yorker* covers, but being chosen to create the cover that commemorates Barack Obama's historic election as the first African American President of the United States is not only flattering, it's beyond humbling," said Staake at the time.

Violência
no trânsito

Isso tem
que ter fim

ZERO HORA

ANO 45
Nº 15.848
SC-PR - R$ 2,50
DEMAIS REGIÕES
R$ 3,50
URUGUAI - S-18

PORTO ALEGRE, **QUARTA-FEIRA**, 21 DE JANEIRO DE 2009 · 2ª EDIÇÃO

www.zerohora.com

R$
2,00

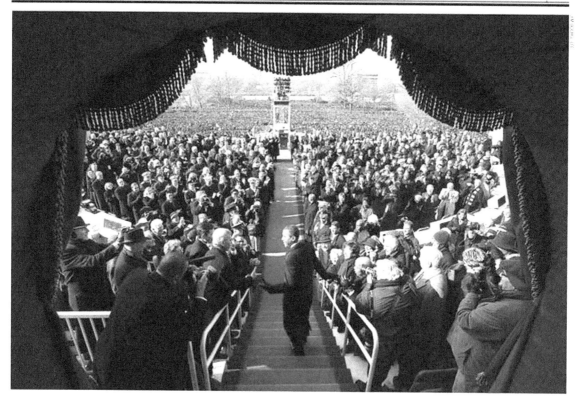

Abre-se a Era Obama

"O mundo mudou e precisamos mudar com ele"

Palco de uma cerimônia histórica, a tribuna do Capitólio (foto) abrigou o discurso realista de Barack Obama, ato inaugural de um 20 de janeiro inesquecível, como relata o Enviado Especial de ZH, Rodrigo Lopes.

ZERO HORA, JANUARY 21, 2009

This beautiful photograph, featured on the cover of the Brazilian newspaper, *Zero Hora*, was taken from a unique vantage point at the rear of the inauguration platform at US Capitol, Washington DC, on January 20, 2009. It captures the immediate prelude to the inauguration ceremony, as Barack Obama descends to the podium where a crowd of over a million people are waiting to witness him being sworn in as president of the United States of America. As the audience of VIPs looks on from the stalls, eager for some of his attention, Obama stops momentarily to shake a hand before moving on — but he can't linger, as the massed crowd below, and also those around the world watching on television, are all waiting for a piece of him. Like a painting, this incredible foreground scene is framed by the aperture of the curtain, neatly clipped back to create the illusion of a magical portal into another world, which only we, the viewer, are privy to.

The New York Times

SUNDAY, JANUARY 25, 2009

Articles selected in association with **The Observer**

A World of Challenges

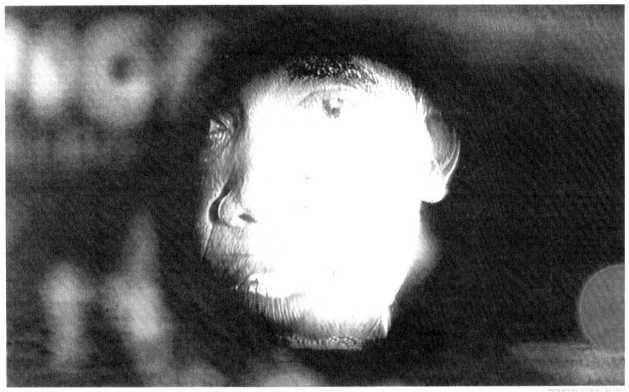

During his two-year journey to the White House, Barack Obama has been obliged to recalibrate his focus as events like the international financial crisis supervened.

NEW YORK TIMES/OBSERVER, JANUARY 25, 2009

This cover of *The New York Times* supplement for the UK's *Observer* newspaper was published just four days after the *Zero Hora* front page featured opposite. It also creates the illusion of a portal. The photograph, shot by *New York Times* staffer Damon Winter, shows President Obama's head framed within a circular keyhole-style perspective, obscuring part of his face in shadow. In contrast to the *Zero Hora* execution, which corrals hundreds of thousands of people within its portal-style view, what we are left with here is a single eerie focal point around one of Obama's eyes and his mouth as he speaks. The circular framing makes us feel as if we are peeping through a hole in a wall, intruding on a secret meeting.

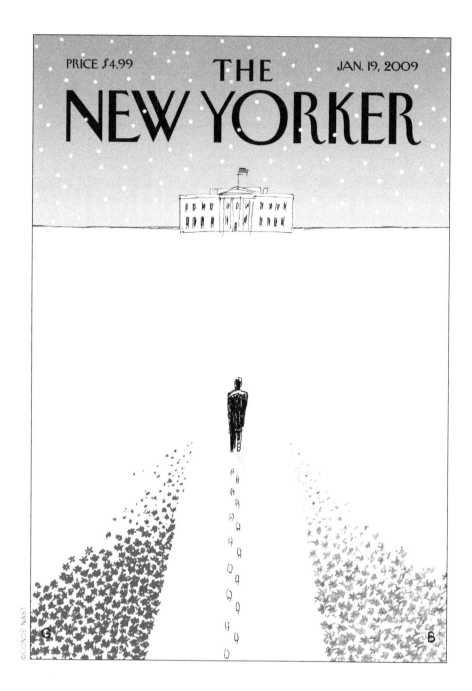

PRICE $4.99

THE NEW YORKER

JAN. 19, 2009

©CONDÉ NAST

THE NEW YORKER, JANUARY 19, 2009
THE TIMES, JANUARY 24, 2009

This cover of *The New Yorker*, by illustrator Guy Billout, revealed the loneliness and isolation of the job Obama had undertaken. He is rendered as a solitary, child-sized figure engulfed in open space, walking through the snow toward the White House, past a red and blue divide (the signature colours of the Republican and Democratic parties) — each step leaving a desolate trail of footprints in his wake. It was a powerful and poignant narrative — that once the fanfare, excitement and rhetoric about Obama's victory was over, the cold, isolating reality of office presented a rude awakening.

The cover of the London *Times* newspaper supplement was published at virtually the same moment as *The New Yorker's* edition. This photograph shows Barack and Michelle Obama approaching the White House on inauguration day. It is a warm, colourful scene as they traverse the blue walkway to their new seat of power. The strength of the image lies in the fact that they are approaching their new adventure together, as husband and wife, holding each other's hands. This is a sharp counterpoint to the sense of isolation and loneliness portrayed in *The New Yorker's* execution.

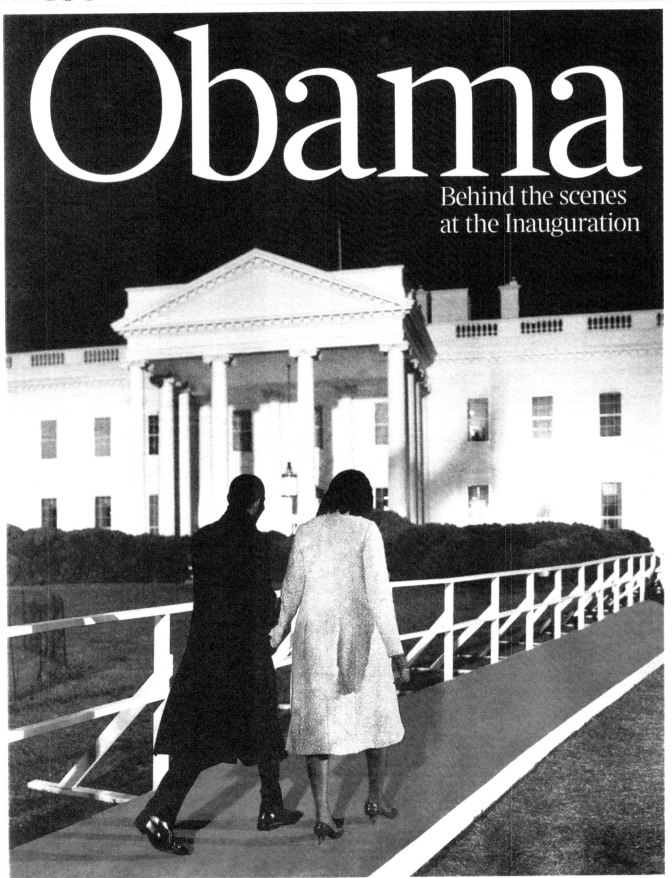

THE TIMES

Obama

Behind the scenes at the Inauguration

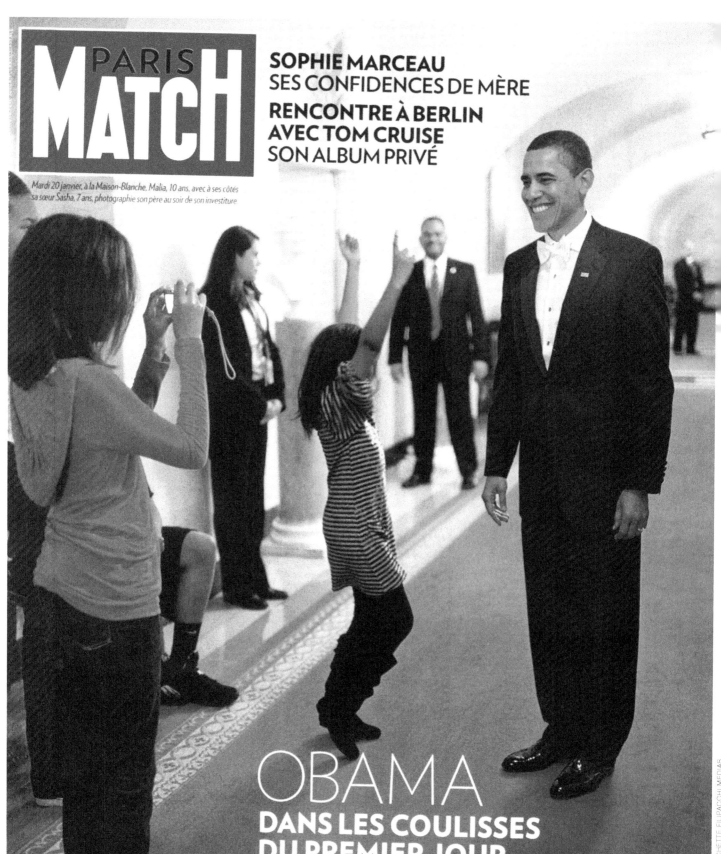

PARIS MATCH

SOPHIE MARCEAU
SES CONFIDENCES DE MÈRE

RENCONTRE À BERLIN
AVEC TOM CRUISE
SON ALBUM PRIVÉ

Mardi 20 janvier, à la Maison-Blanche, Malia, 10 ans, avec à ses côtés
sa sœur Sasha, 7 ans, photographie son père au soir de son investiture

OBAMA
DANS LES COULISSES
DU PREMIER JOUR

This cover features a photograph of President Obama and his daughters at the White House on inauguration night, January 20, 2009. It is a candid behind-the-scenes moment, with Malia capturing a souvenir shot of her proud father in his tuxedo, while Sasha celebrates the fact that her dad is the new president of the United States, thrusting both arms into the air as if she is dancing at a rock concert. It is a joyful family moment, played out against the backdrop of the White House security staff on duty.

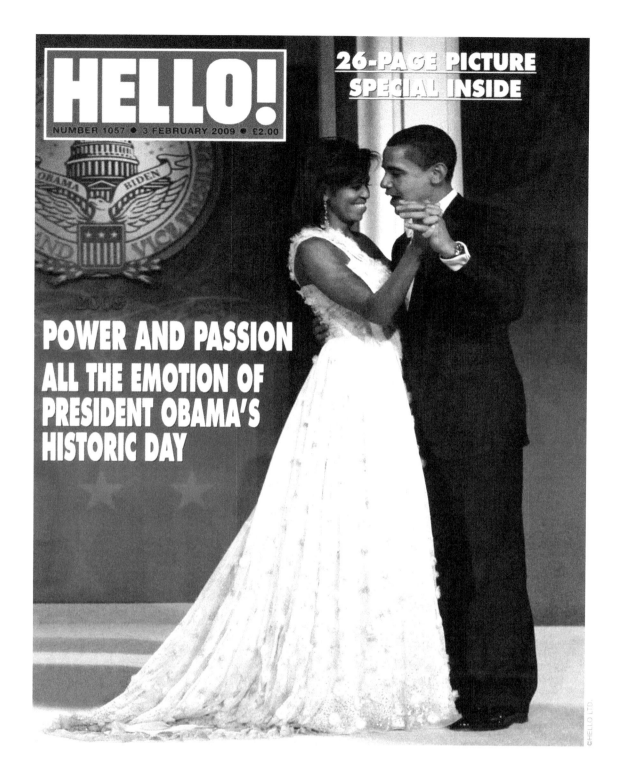

These covers feature the First Lady and the commander-in-chief on inauguration night 2009, taking the opening dance at the Neighbourhood Ball. The couple graced the stage to the Etta James classic, "At Last", sung live by Beyoncé. Although the moment appears to be quite intimate, they are in fact being watched by thousands of guests seated in the audience. "Everyone was crying," said Mary J. Blige, one of the night's performers. Almost everybody present for the occasion was a superstar — it was like Oscar night, in which one candidate had scooped all the prizes.

Michelle Obama surprised fashion experts by wearing a full-length ivory-coloured ball-gown by then little-known American designer, Jason Wu. He had no idea that the First Lady had opted to wear his Swarovski crystal-and-organza creation until he saw her on television that night, as he sat at home eating pizza.

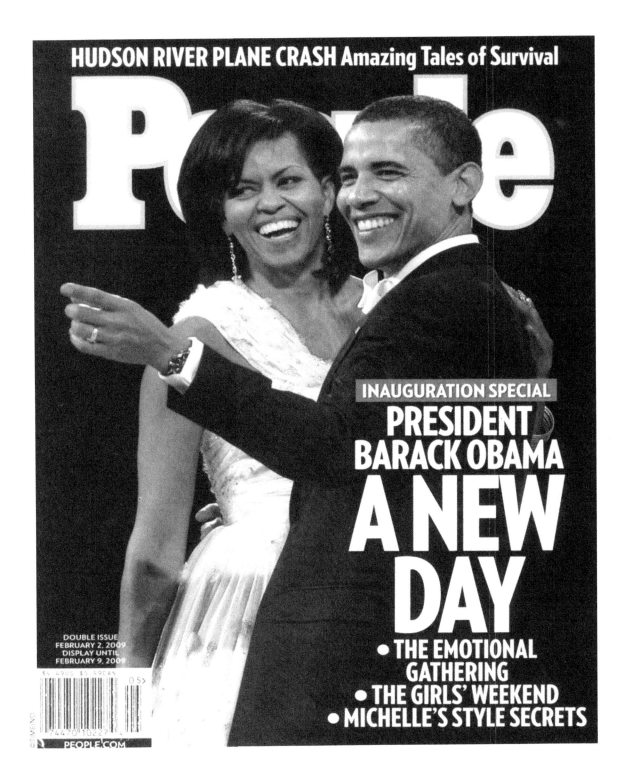

HUDSON RIVER PLANE CRASH Amazing Tales of Survival

People

INAUGURATION SPECIAL
PRESIDENT BARACK OBAMA
A NEW DAY
- **THE EMOTIONAL GATHERING**
- **THE GIRLS' WEEKEND**
- **MICHELLE'S STYLE SECRETS**

DOUBLE ISSUE
FEBRUARY 2, 2009
DISPLAY UNTIL
FEBRUARY 9, 2009

PEOPLE.COM

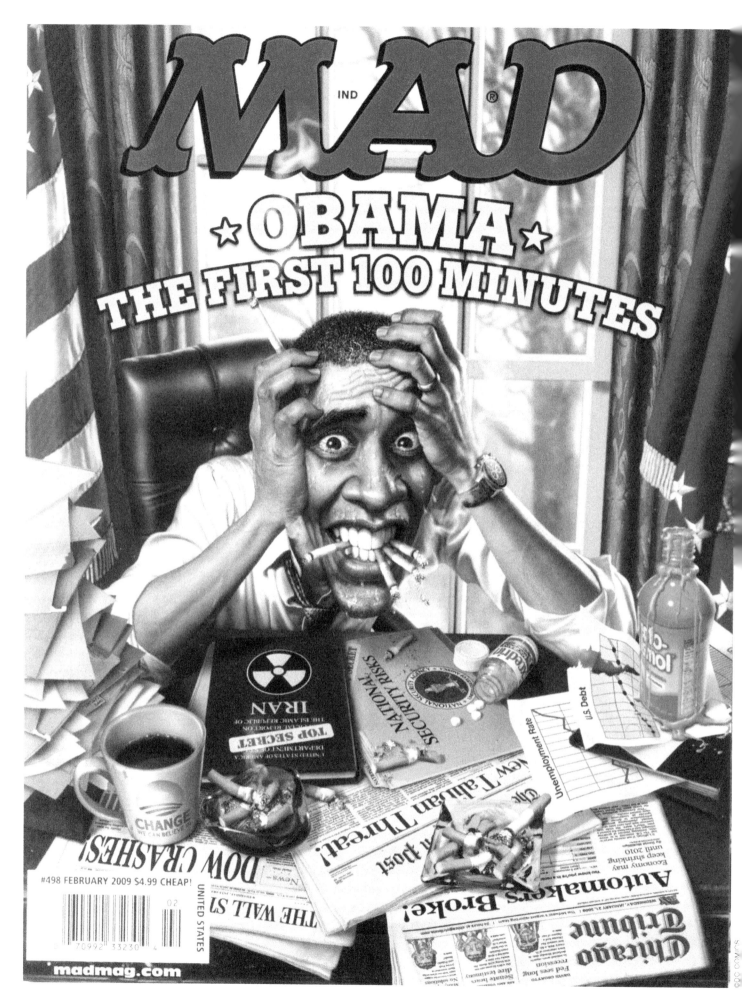

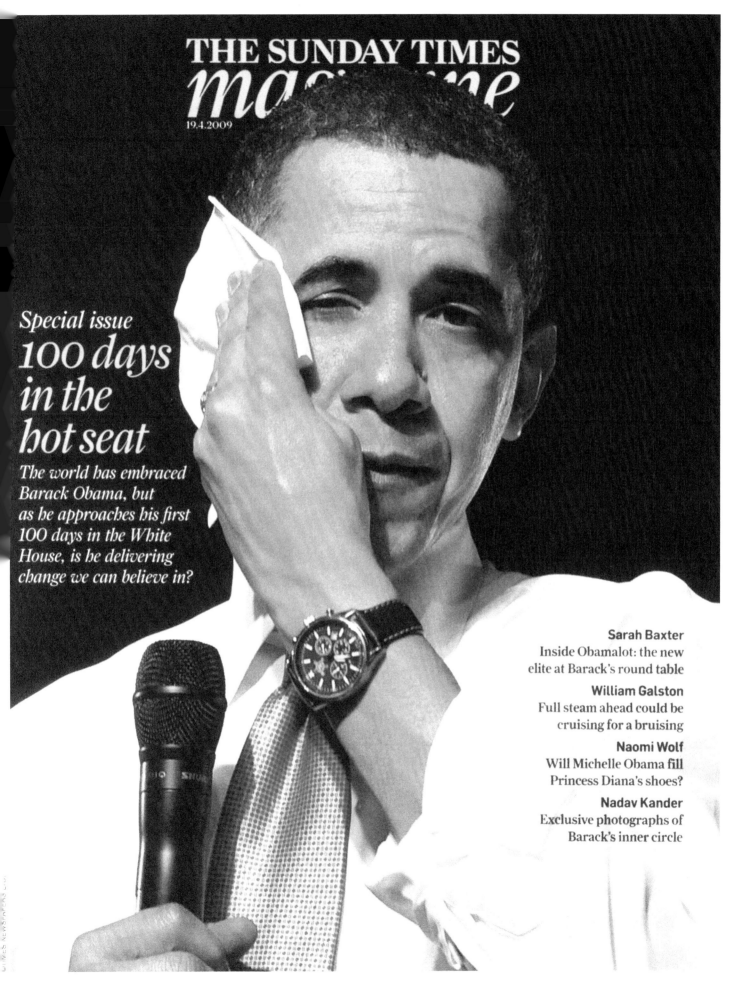

THE SUNDAY TIMES
magazine

19.4.2009

Special issue
100 *days* in the hot seat

The world has embraced Barack Obama, but as he approaches his first 100 days in the White House, is he delivering change we can believe in?

Sarah Baxter
Inside Obamalot: the new elite at Barack's round table

William Galston
Full steam ahead could be cruising for a bruising

Naomi Wolf
Will Michelle Obama fill Princess Diana's shoes?

Nadav Kander
Exclusive photographs of Barack's inner circle

After the party came the pressure. As soon as the inauguration celebrations were over, President Obama began to feel the searing heat of office. His first "100 days in the hot seat" is the subject of this cover from the British *Sunday Times Magazine*. The image is stark in contrast to the euphoric post-election front pages of 2008. The photograph tells its own story, depicting the president wiping sweat from his forehead, feeling the pressure to deliver on expectations. The composition marked the press's inevitable switch away from Obama's depiction as the messiah, our modern-day saviour and towards that of a mortal man who might fail to deliver under the weight of the world's expectations.

Mad magazine's skilful take on President Barack Obama's "first 100 minutes" in office is one of the most humorous examples of the period. It depicts a stressed-out president on the brink of madness, puffing desperately on multiple cigarettes as he contemplates the daunting task ahead of him.

ROLLING STONE, AUGUST 20, 2009

The August edition of *Rolling Stone* features an illustration of the president as a worried figure looking pensively into the distance, the pressures of office already taking their toll on him. His head is encircled by the Seal of the President of the United States, inside of which the text has been altered in line with the story inside. The Seal also cleverly doubles as a discoloured halo, suggesting that the superhero sheen that once surrounded the statesman prior to being elected has finally worn off. The headline, "Obama So Far", previews a roundtable assessment of his performance as leader.

RollingStone

Issue 1085
August 20, 2009 •• $4.99

Michael Jackson
The Latest Revelations

WILL HE TAKE BOLD ACTION OR COMPROMISE TOO EASILY?

A ROUNDTABLE

David Gergen
Paul Krugman
Michael Moore

OBAMA SO FAR

In an era in which press cartoons can cause offence in ways unforeseen by their authors, this cover of *The New Yorker* made news headlines across America just hours after it hit newsstands on the morning of July 13, 2008. The cartoon, by illustrator Barry Blitt, was entitled "The Politics of Fear", and depicted the Obamas as terrorists in the Oval Office. The image shows the senator, who is a Christian, dressed in traditional Muslim clothing, while his wife is rendered — like a ringer for Sixties black nationalist Angela Davis — in Black-Panther-style military fatigues, complete with a voluminous afro, plus an AK-47 slung over her shoulder. The pair exchange a "fist-bump" while an American flag burns in the fireplace beneath a portrait of Osama Bin Laden hanging on the wall. The couple appear to be celebrating, presumably having succeeded in fooling the American electorate into voting for them, without realising what lies beneath. The much-referred-to fist-bump alluded to the campaign rally in St. Paul Minnesota on June 6, 2008, when the couple were first seen to touch knuckles.

In the days that followed the edition's release, dissenting voices began to chime in. Dee Dee Myers, writing for *Vanity Fair*, contended that while most classic press caricatures of past presidents usually have some basis in fact, the Obama cartoon was predicated entirely on fabrication. Barack Obama's camp also protested. Spokesperson Bill Burton condemned the illustration as "tasteless and offensive." Obama himself, who had initially kept silent, eventually commented on CNN's *Larry King Live*, playing down the importance of the cartoon while suggesting that it derided Muslim-Americans. He also questioned whether or not such an execution had the opposite effect to that which had been intended. "I do think that in attempting to satirize something they probably fuelled some misconceptions about me instead," he claimed.

The cover also drew strong reactions from cartoonists. "Since readers expect cartoonists to convey some truth as we see it, depicting someone else's point of view in a cartoon has to be shown to be someone else's point of view," said MSNBC's political cartoonist Daryl Cagle. Others expressed their opinion not with words but pictures. *Vanity Fair* illustrator Tim Bower, and Stephff from *The Nation* brought some much needed humour to the situation by spoofing Blitt's cover for their respective publications.

There were other less critical voices about Blitt's cartoon from some unlikely quarters of the African American press. Clarence Page, veteran columnist on *The Chicago Tribune*, stated that the cover was "quite within the normal bounds of journalism", while George Curry, *Philadelphia Enquirer* columnist and former president of the Society of Magazine Editors, said, "This is political satire. If you're a public official, be prepared for it."

The day after its release, Internet searches for the cover image peaked at number 19 on Google Trends top 20. The controversy propelled newsstand sales of the issue to record levels. *The New York Post* reported a sell-out, with sales surging by 80 per cent, and with the magazine struggling to keep up with demand. In just a few hours *The New Yorker*, the bastion of the American literary establishment, had become the bad boy of American publishing.

Negative reaction to the cover was so intense that editor David Remnick was forced to come out in its defence. "What I think it does is hold up a mirror to the prejudice and dark imaginings about Barack Obama's — both Obamas' — past and their politics," he stated. "It combines a number of images that have been propagated, not by everyone on the right but by some, about Obama's supposed 'lack of patriotism' or his being 'soft on terrorism' or the idiotic notion that somehow Michelle Obama is the second coming of the Weathermen or most violent Black Panthers. That somehow all this is going to come to the Oval Office."

In the run up to the 2008 election these untruths were indeed circulating. The most common of the falsehoods was the accusation that Obama was a Muslim. A *Newsweek* poll in July 2008 stated that 12 per cent of voters surveyed believed, incorrectly, that Obama was sworn in as a US Senator using a Qur'an, while 26 per cent believed he was raised as a Muslim, and 39 per cent believed he'd attended an Islamic school as a child. Added to this were comments by conservative "shock jocks" such as Rush Limbaugh, who let it slip in September 2008 that he occasionally got "confused" between Obama and Osama.

"The fact is, it's not a satire about Obama," Remnick stated in reference to the cartoon. "It's a satire about the distortions and misconceptions and prejudices about Obama." But many just didn't get it. Confusion arose amongst many because the perpetrators of the misconceptions to which Remnick referred were absent from the cartoon. Instead, by using the image of the Obamas to illustrate the point, it appeared as if the magazine was gunning for them, rather than the right-wing fear-mongers it was intended to expose. Remnick's real message, perhaps too obtuse for some, was that the cartoon was actually pro-Obama — like the majority of *The New Yorker*'s editorial coverage throughout his campaign.

The sheer number of misinterpretations of the illustration lead to suggestions that a greater explanation of intent was necessary from the magazine in such cases of controversy. "Satire doesn't run with subtitles," Remnick countered wryly. "A satirical cartoon would not be any good if it came with a set of instructions."

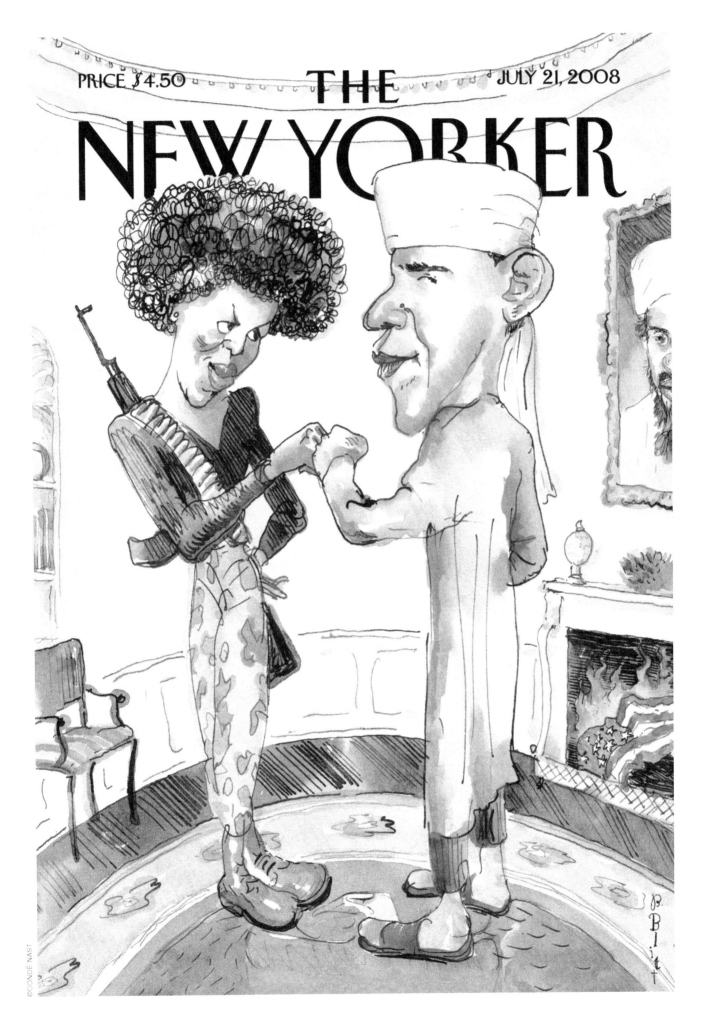

THE NEW YORKER

SEPTEMBER 28, 2009

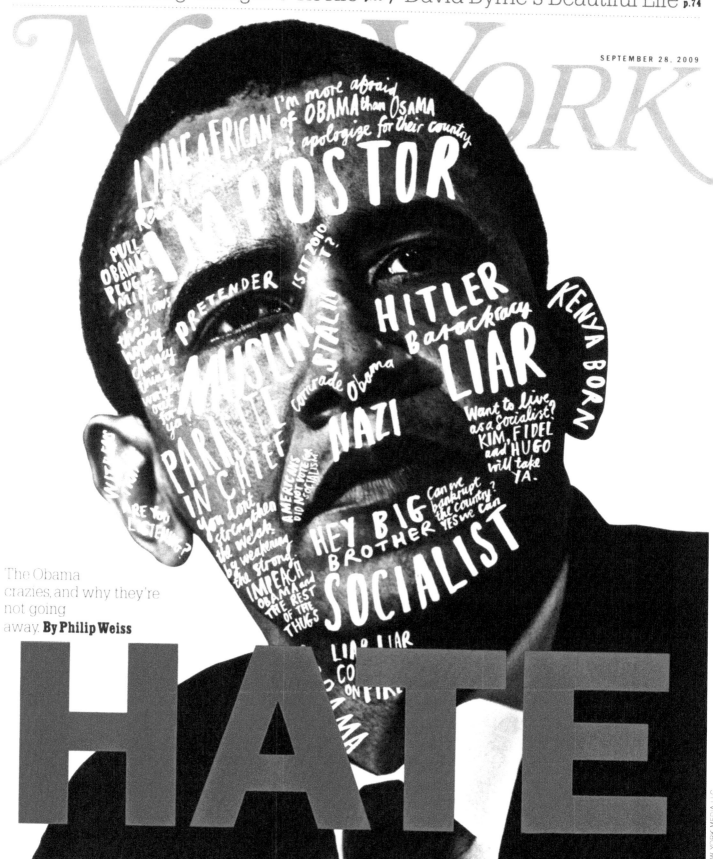

The Obama
crazies, and why they're
not going
away. **By Philip Weiss**

HATE

©NEW YORK MEDIA LLC

Just months after Obama took office, the backlash had begun. *New York* magazine appropriated artist Shepard Fairey's famous Obama "HOPE" poster, (see page 109) turning it on its head to reflect the discontent felt about the new president within certain quarters. Their Keith-Haring-style artwork consists of a portrait of the president's face graffiti-ed with words such as "Hitler", "Nazi" and "Muslim". The word "HOPE", from Fairey's original poster, is replaced by "HATE". The cover — voted the most controversial of 2009 by the American Society of Magazine Editors — was criticised for its depiction of the president. The magazine's editors maintained that the words used reflected, not their views, but those of a section of Obama's dissenters. The lead story attempted to establish this position with its opening line, "Why do people say such loopy, ugly things about him [Obama]?" But this was lost on outraged spectators, who saw the cover as an attack by the magazine itself, and one which would only serve to perpetuate prevailing misconceptions and untruths about the president.

mensile | n. 108

RollingStone

Obama²

INTERVISTA ESCLUSIVA L'uomo più potente del mondo apre lo Studio Ovale al fondatore di "Rolling Stone", Jann S. Wenner. Per una chiacchierata (anche) su quelle sere rock&roll con Mick Jagger, Paul McCartney, Herbie Hancock...

JOHNNY ROTTEN
«AVEVO I DENTI MARCI.
ORA LI HO TUTTI NUOVI
MA CADONO LO STESSO»

CAT POWER
«VOLEVO UN MITO NEL
MIO NUOVO ALBUM: IGGY
HA DETTO SI, DAVID NO»

JOHNNY RAMONE
IN ANTEPRIMA IL PEZZO
PIÙ BELLO DELLA SUA
AUTOBIOGRAFIA "COMMANDO"

MUMFORD & SONS
CITANO SHAKESPEARE
E LA BIBBIA. EPPURE
FINISCONO IN CLASSIFICA

LINKIESTA
CON LA LAUREA IN TASCA LA
VITA È PIÙ FACILE? DIPENDE.
DI CERTO È PIÙ COSTOSA

DON WINSLOW
«HO UNA REGOLA: SCRIVERE
10 PAGINE AL GIORNO. PERÒ
DI SOLITO MI FERMO A 5...»

Foto di — NADAV KANDER

©WENNER MEDIA LLC

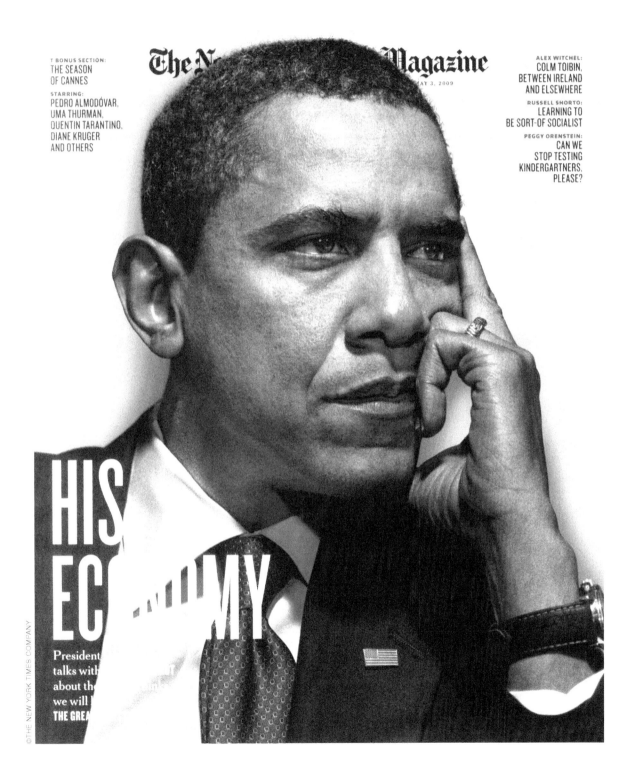

"You're so handsome that I can't speak properly," said actress Gwyneth Paltrow to Barack Obama at a Democratic Party fundraiser held at her Los Angeles home in October 2014. These two covers best illustrate what sent Paltrow into such a spin. Both of them were shot for *The New York Times* by acclaimed London-based photographer Nadav Kander. The cover of *Rolling Stone* (Italy) was taken in 2009, just after Obama's first election victory, as part of a special edition of 52 portraits of members of his newly-appointed administration. The close-up image of the president's face — selected by the magazine to mark his imminent second term — shows Obama glancing away from camera, seemingly in the midst of a conversation, looking alert and youthful.

The adjacent portrait for *The New York Times Magazine* was taken just months later, during an interview with the newspaper that took place at the Oval Office on April 14, 2009. The image was captured as Obama listened to questions from *Times* interviewer David Leonhardt. The intense focus of his gaze, the shape of his hand pressed against his face and the angled profile of his head, all combine to show the president at his most charismatic, and handsome.

PHOTO, SEPTEMBER 2009

This cover, along with the previous two, completes a trilogy that best illustrates the power of Obama's sex appeal. In typical French fashion, *Photo* magazine opted for style and elegance for their September 2009 Obama cover. The image, captured by British photographer Platon, shows the president immaculately attired, staring straight at us while striking a powerful angular pose, with his arms and legs positioned diagonally around his torso.

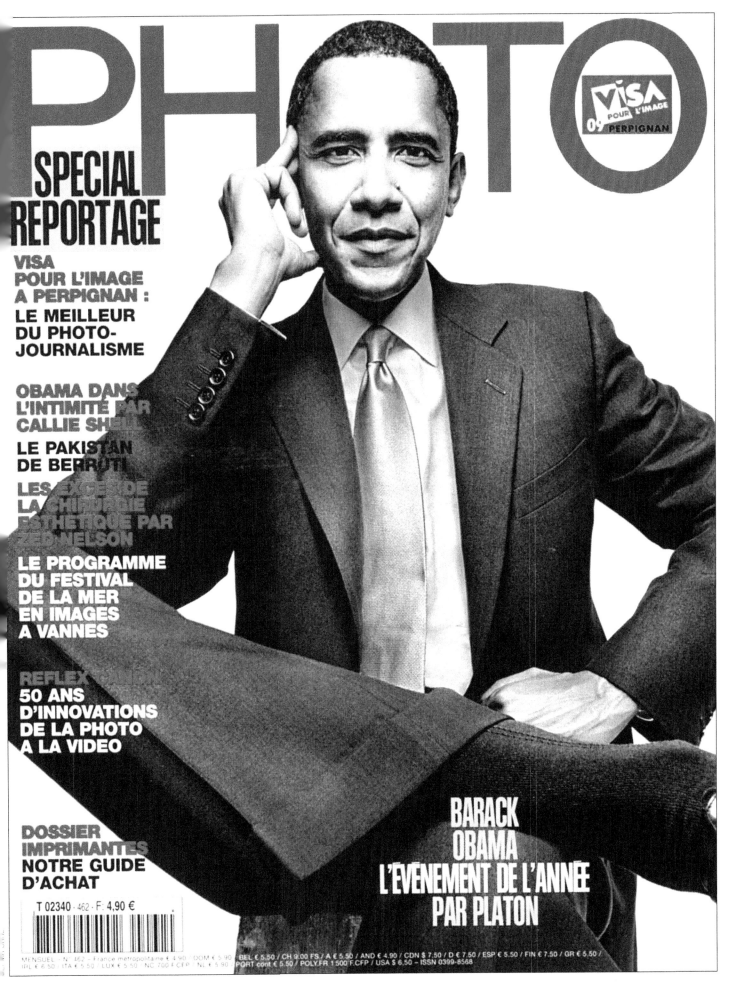

PH○TO

VISA
POUR L'IMAGE
09 PERPIGNAN

SPECIAL
REPORTAGE

**VISA
POUR L'IMAGE
A PERPIGNAN :**
LE MEILLEUR
DU PHOTO-
JOURNALISME

**OBAMA DANS
L'INTIMITÉ PAR
CALLIE SHELL**

LE PAKISTAN
DE BERRUTI

LES EXCÈS DE
LA CHIRURGIE
ESTHÉTIQUE PAR
ZED NELSON

**LE PROGRAMME
DU FESTIVAL
DE LA MER
EN IMAGES
A VANNES**

REFLEX CANON
**50 ANS
D'INNOVATIONS
DE LA PHOTO
A LA VIDEO**

**DOSSIER
IMPRIMANTES
NOTRE GUIDE
D'ACHAT**

T 02340 · 462 · F: 4,90 €

BARACK
OBAMA
L'EVENEMENT DE L'ANNÉE
PAR PLATON

MENSUEL - N° 462 - France métropolitaine € 4.90 - DOM € 5.90 / BEL € 5.50 / CH 9.00 FS / A € 5.50 / AND € 4.90 / CDN $ 7.50 / D € 7.50 / ESP € 5.50 / FIN € 7.50 / GR € 5.50 /
IRL € 6.50 / ITA € 5.50 / LUX € 5.50 / NO 700 F.CFP / NL € 5.90 / PORT cont € 5.50 / POLY.FR 1 500 F.CFP / USA $ 6.50 - ISSN 0399-8568

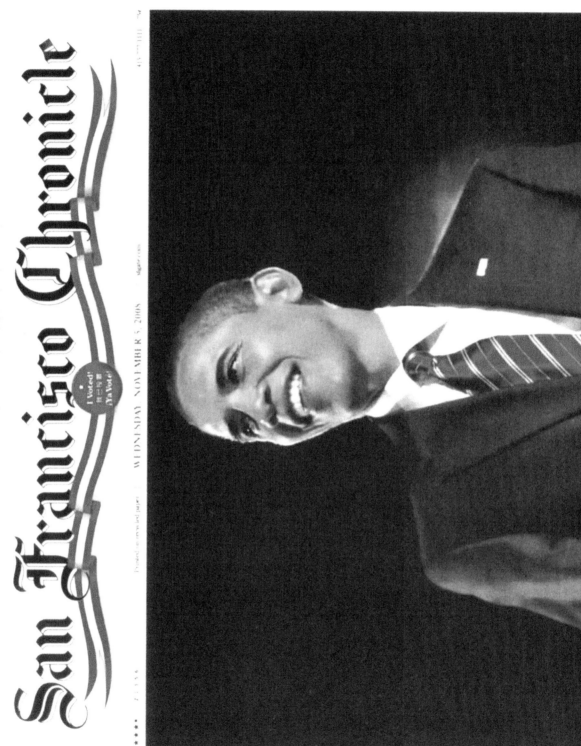

San Francisco Chronicle

ELECTION 2008: COVERAGE BEGINS ON PAGE A3

WEDNESDAY, NOVEMBER 5, 2008

OBAMA
"CHANGE HAS COME TO AMERICA"

President-elect Barack Obama in his victory speech in Chicago

SAN FRANCISCO CHRONICLE, NOVEMBER 5, 2008

The *San Francisco Chronicle's* giant-sized post-election front page presented a flattering depiction of the new president. It consists of a full-body shot of Obama set against an atmospheric black sky, with a subtle flare of white light fizzing over his right shoulder. The rich sheen of his suit and the angle of the pose all add to the drama and charisma of the set piece. The cover lines, pulled to the bottom of the page, clear of the image, complete what is more like a pin-up than a regular newspaper front page.

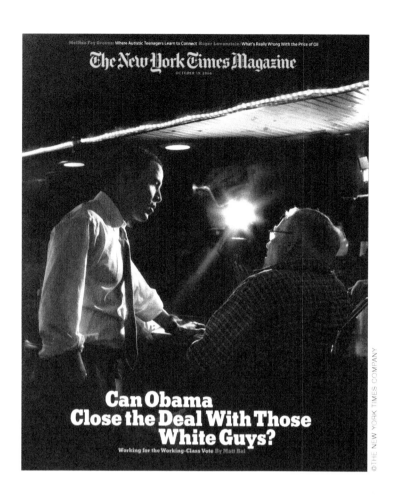

THE NEW YORK TIMES MAGAZINE, OCTOBER 19, 2008
THE NEW REPUBLIC, MAY 28, 2008

These covers use contrasting images to discuss the same pre-election topic — will whites vote for an African American presidential candidate? Photographer Samantha Appleton's image for *The New York Times* magazine shows Obama in a relaxed moment talking to a white voter while out on the campaign trail. The headline, "Can Obama Close The Deal With Those White Guys?" sets up the intrigue of the story inside. By contrast, *The New Republic*'s treatment is a paint-by-numbers construction by illustrator David Cowles, consisting of an "unfinished" rendering of a portrait of the Democratic candidate. The designer has rendered the senator with a form of "digital vitiligo", with patches of his skin faded to white.

The New
REPUBLIC

MAY 28, 2008 • $4.95

WILL
WHITES
VOTE
FOR HIM?
THE POLITICAL
PSYCHOLOGY
OF RACE
JOHN B. JUDIS

THE CAMPAIGN
HE *SHOULD*
RUN
THE EDITORS

THE
STUPIDITY
OF DIGNITY
STEVEN PINKER

HILLARY
RELIVES
IMPEACHMENT
MICHAEL CROWLEY

LIONEL
TRILLING'S
DREAM
CYNTHIA OZICK

NICHOLSON
BAKER'S SHAME
ANNE APPLEBAUM

Plus
CINQUE
HENDERSON
INGRID D.
ROWLAND
HELEN
VENDLER
LEON
WIESELTIER

✴ *TNR.com*

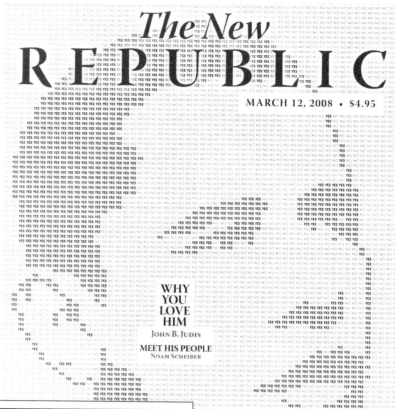

The New
REPUBLIC

MARCH 12, 2008 • $4.95

WHY
YOU
LOVE
HIM
John B. Judis

MEET HIS PEOPLE
Noam Scheiber

Plus
THE JEWISH KING LEAR
Stephen Greenblatt

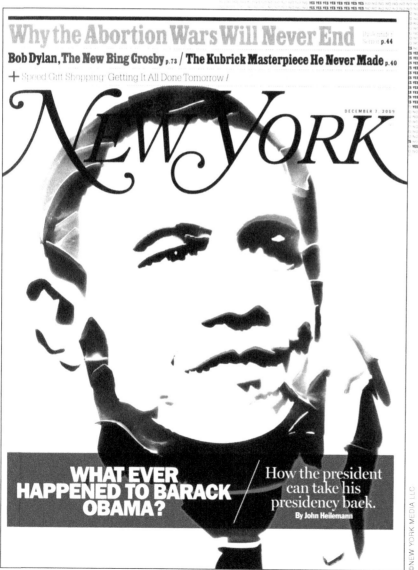

Why the Abortion Wars Will Never End p.44

Bob Dylan, The New Bing Crosby p.73 / The Kubrick Masterpiece He Never Made p.40

+ Speed Gift Shopping: Getting It All Done Tomorrow /

NEW YORK

DECEMBER 7, 2009

WHAT EVER
HAPPENED TO BARACK
OBAMA?

How the president
can take his
presidency back.
By John Heilemann

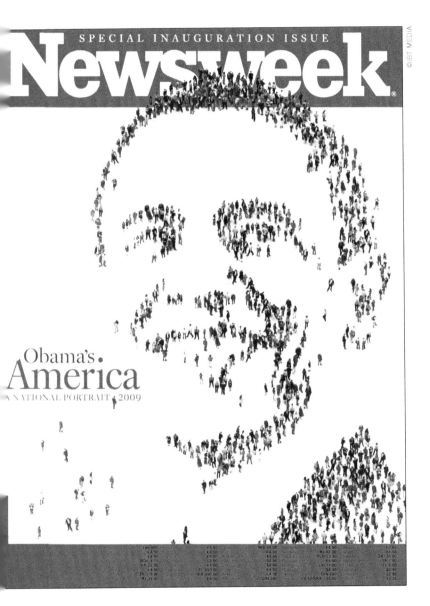

NEW YORK, DECEMBER 7, 2009
THE NEW REPUBLIC, MARCH 12, 2008
NEWSWEEK, JANUARY 26, 2009

These atmospheric artworks reject the traditional use of portrait photography, setting themselves apart from the competition. The cover of *New York* magazine, under the headline, "Whatever Happened To Barack Obama?" shows the president as a compromised, fading force, illustrated via a washed out, facsimile-style rendering of his face. The reader is left with the impression that the image will continue to ebb away until it fades completely, leaving a stark white page.

The New Republic's front cover, by graphic design studio The Heads Of State, is a cleverly composed image consisting entirely of words. The darker patches within the rendering are made up of tiny repetitions of the word "YES", while the lighter shades are formed from the word "NO". The artwork offered an original method of illustrating the dilemma about which way the vote would swing in the 2008 election.

Newsweek's special inauguration edition of 2009 features artwork by illustrator Bryan Christie, in which Obama's likeness has been subtly composed from hundreds of tiny ant-like images of people, shot from above and carefully positioned to form the president's facial features. The cover appears to be alive, as if the people who make up the composition are still moving, and might spontaneously reshuffle to form another face entirely.

Like no other president before him, Barack Obama's reach as a cover star was not simply confined to the mainstream press but also extended to comic books — the result of his broad appeal amongst the younger generation. The idea for *The Amazing Spider-Man,* released on January 14, 2009, came about after Marvel Comics executives learned that Obama had been a fan of the wall-crawler since his youth. "Barack Obama collected *Spider-Man* comics as a child, so Marvel Comics wanted to give him a shout-out back by featuring him in a bonus story," said Joe Quesada, Marvel's editor-in-chief. "It was really cool to see that we had a geek in the White House."

Further responses from readers cemented the idea for the cover story. "We got tons of questions about it," said *Spider-Man* editor Steve Wacker. "I got a bunch of jpegs sent to me, Photoshopped with Obama reading *Spider-Man.* So we thought, after the election, with the inauguration coming up, we decided to have him meet Spider-Man in person."

The front cover of edition 583, by artist Phil Jimenez, features a youthful Obama giving the thumbs-up as Spider-Man, suspended upside down in the background, takes his picture and quips, "Hey, if you get to be on my cover, can I be on the dollar bill?" Inside is a six-page story that Wacker and writer Zeb Wells pulled together in just one week following the election. It focuses on a plot by Spider-Man's enemy The Chameleon, to impersonate Obama at his inauguration and take over the country. The super-hero and the politician team up against him. By the end, as they overcome the villain, the duo bump fists in celebration.

Obama joined a small but notable group of American presidents who have appeared in comics in the past, including John F. Kennedy, FDR, Ronald Reagan and Bill Clinton. But this was the first time a president-elect had ever featured on a Marvel cover. Synthesizing reality into the fantasy world of comics is more traditional than one might think, and the *Spider-Man* series has always operated within the vernacular of real-time New York. "The natural extension of that is you start seeding in pieces of the real world," said Wacker.

The special edition was widely reported internationally a week before its due date. Quesada appeared on CNN three times in 24 hours to promote it, and the story made the front pages of several newspapers. At the same time, the Obama cover was in short supply, as it was originally printed as a special edition, or "variant", alongside the magazine's regular cover, and many retailers did not stock it, as they were required to pre-order it in addition to their regular monthly consignment.

The pre-press hype and the restricted supply sparked an international scramble for pre-orders amongst comic book geeks, collectors and Obama devotees alike. Comics stores across America and Europe that had ordered the variant sold out of their consignment before it had even arrived. Quick thinking eBay resellers took advantage by offering their advance copies. On January 10, 2009, four days before the comic was officially released, one re-seller posted his virtual copy on the site for sale at $100, up from its purchase price of $3.99.

When the edition finally did hit the streets four days later, thousands of buyers — many of whom never normally frequented comic book stores — came out in their droves. Obama geeks lined up next to Spider-Man geeks as retailers across the country reported record sales, with both editions of the comic selling out immediately. At New York's Midtown Comics store dozens of eager buyers waited outside in the freezing conditions as if they were queueing at a soup kitchen, while a makeshift doorman regulated their entry to avoid a stampede. Tate Comics in Lauderhill, Florida sold their entire consignment of 500 units in less than four hours. "This is an historic moment in *Spider-Man* and in the real world," said manager Joann Minieri.

The day after the frenzy there were 1,200 copies for sale on eBay, the most expensive of which was $300. Marvel, their sales boosted beyond belief, responded quickly to the overwhelming demand by printing a further four variants of the Obama cover over subsequent months, each time with different coloured backgrounds and illustrative variations to distinguish them from each other.

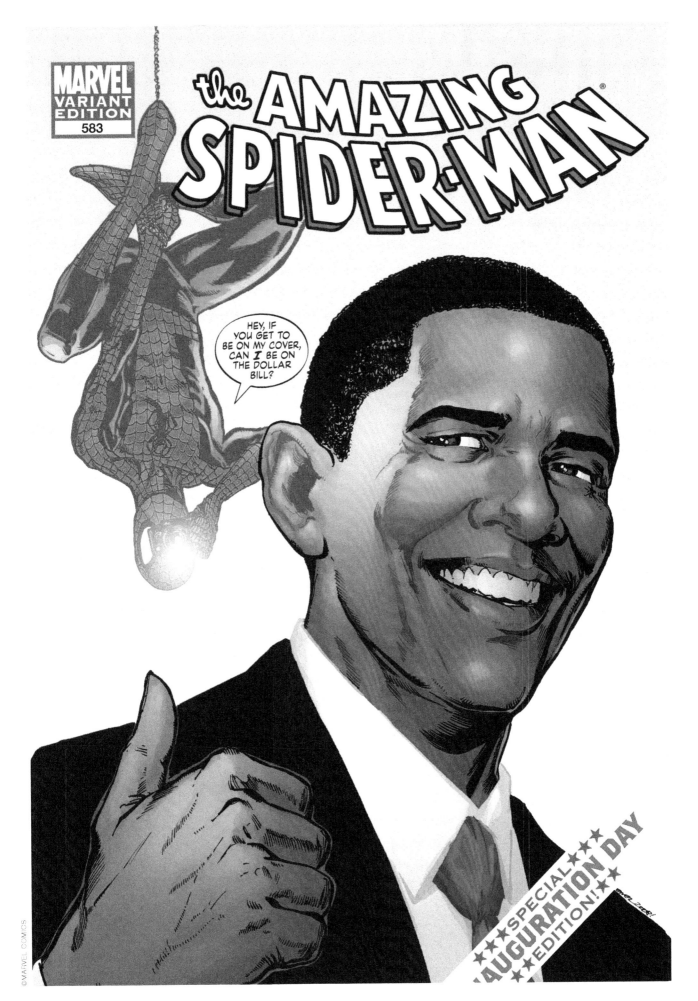

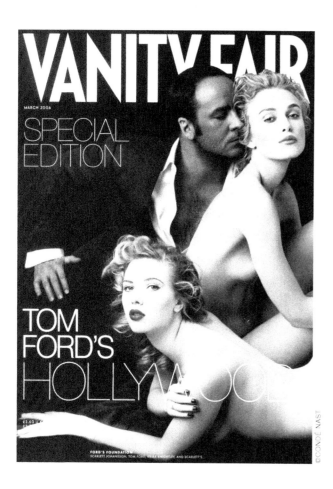

RADAR, NOVEMBER 2007

This cover illustrates the power of Photoshop in creating fantasy scenarios. *Radar* magazine (which closed in 2008) spoofs *Vanity Fair's* notorious March 2006 Hollywood issue front page (featured above) that profiled fashion designer Tom Ford alongside actresses Keira Knightley and Scarlett Johansson, both of whom posed nude. *Radar's* humorous version replaces Ford with former New York mayor Rudy Giuliani, Knightley with Hillary Clinton and Johansson with a montage of a reclining Barack Obama. The execution was intended as a comment on the contention that modern politicians are as manufactured as Hollywood stars.

FRESH INTELLIGENCE

RADAR

NOVEMBER 2007

THE
POLITICS
ISSUE

**The Devil in
Kate Moss**

**The Lit
World's New
It Girls**

**Inside the
CIA's Secret
Prisons**

20 PAGES OF
MUD-SLINGING!
DIRTY TRICKS!
NAKED AMBITION!

*"All is vanity.
Nothing is fair."*

WHO WOULD JESUS VOTE FOR?
Find Out in Our Groundbreaking 2008 Election Poll

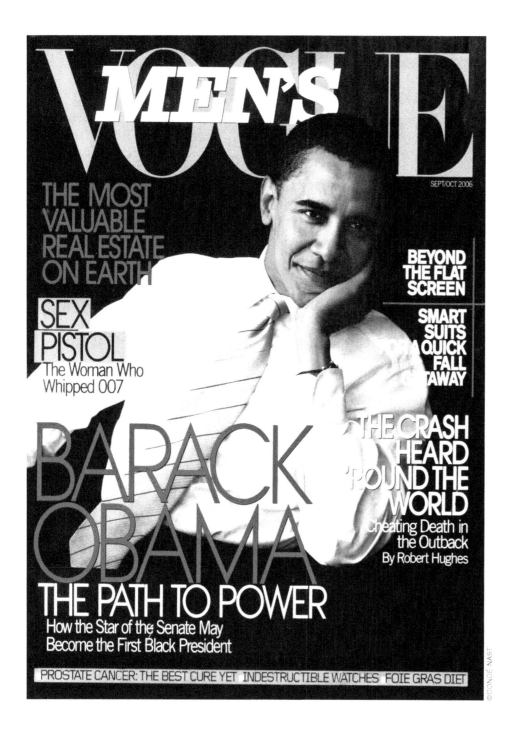

MEN'S VOGUE, SEPTEMBER/OCTOBER 2006 & OCTOBER 2008

Launched on September 6, 2005, *Men's Vogue* began brightly with its cocktail of male celebrities, power-brokers and men of style. It featured the senator on its cover twice within its first two years. The September/October 2006 cover was shot by Annie Leibovitz and shows Barack Obama in casual repose, looking relaxed and friendly, as if he is listening to you, the electorate. Despite the fact that he had yet to declare that he would run for the Oval Office, the edition drew special attention from African Americans, as it was rare for a non-white celebrity to grace the cover of any of *Vogue*'s various editions. The issue sold 129,582 copies — the magazine's best performance aside from its debut issue, which was on newsstands for much longer. By contrast, the October 2008 cover, again shot by Leibovitz, features Obama in a more stern and businesslike guise, posing between engagements on his private jet, with his body angled toward camera. The photograph's most telling feature is the senator's determined fist resting on the arm of his seat.

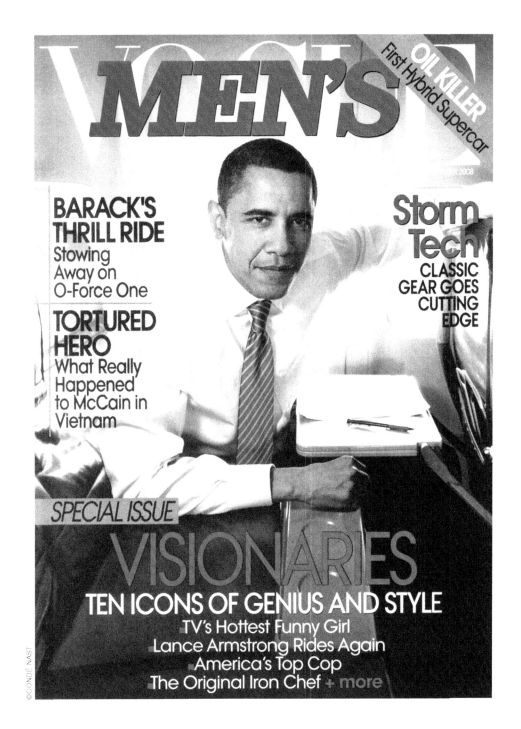

VOGUE MEN'S

OIL KILLER
First Hybrid Supercar

BARACK'S THRILL RIDE
Stowing Away on O-Force One

TORTURED HERO
What Really Happened to McCain in Vietnam

Storm Tech
CLASSIC GEAR GOES CUTTING EDGE

SPECIAL ISSUE

VISIONARIES

TEN ICONS OF GENIUS AND STYLE
TV's Hottest Funny Girl
Lance Armstrong Rides Again
America's Top Cop
The Original Iron Chef + more

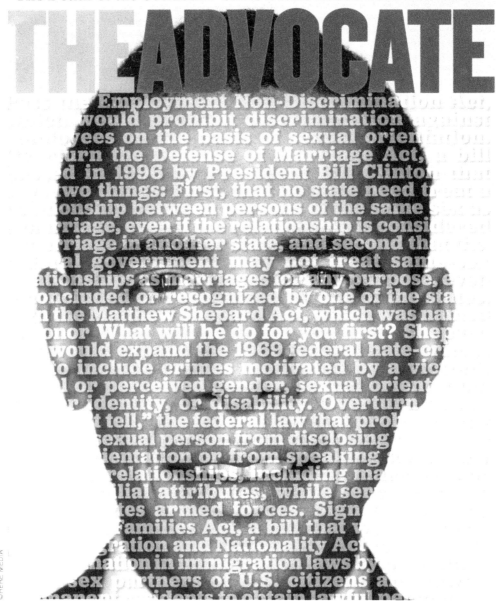

The Death of the Condom // Chris Evans Needs Your Attention

THE ADVOCATE

Employment Non-Discrimination Act,
would prohibit discrimination
yees on the basis of sexual orientation
urn the Defense of Marriage Act, a bill
d in 1996 by President Bill Clinton that
two things: First, that no state need t
onship between persons of the same s
rriage, even if the relationship is consi
rriage in another state, and second th
al government may not treat san
ationships as marriages for any purpose, e
oncluded or recognized by one of the sta
n the Matthew Shepard Act, which was nan
onor What will he do for you first? Shep
would expand the 1969 federal hate-cr
o include crimes motivated by a vic
l or perceived gender, sexual orient
r identity, or disability. Overturn
t tell," the federal law that prol
exual person from disclosing
ientation or from speaking
relationships, including ma
lial attributes, while ser
es armed forces. Sign
families Act, a bill that w
ration and Nationality Act
ation in immigration laws by
sex partners of U.S. citizens a
anent residents to obtain lawful pe

©HERE MEDIA

THE ADVOCATE, FEBRUARY 2009
THE ATLANTIC, DECEMBER 2007

These ingenious collages combine strong colour photography and typography to create arresting images. The February edition of gay and transgender magazine *The Advocate* cleverly uses translucent typography laid over a colour portrait of Obama's face, giving it a grainy, gritty texture. The strapline, "What will he do for you first?", punches out at us in yellow, amidst the muted colours surrounding it.

The cover of *The Atlantic* features a ghostly portrait of the senator, shot through with miniatures of political figures past and present. His face appears to absorb all the energy of their collective history directly into his own persona. The image is transformed by this superimposition, its blocky texture reminiscent of the face of the Thing from the Fantastic Four comic books, or else a portrait by painter Chuck Close. The issue became the magazine's best-selling cover of the year.

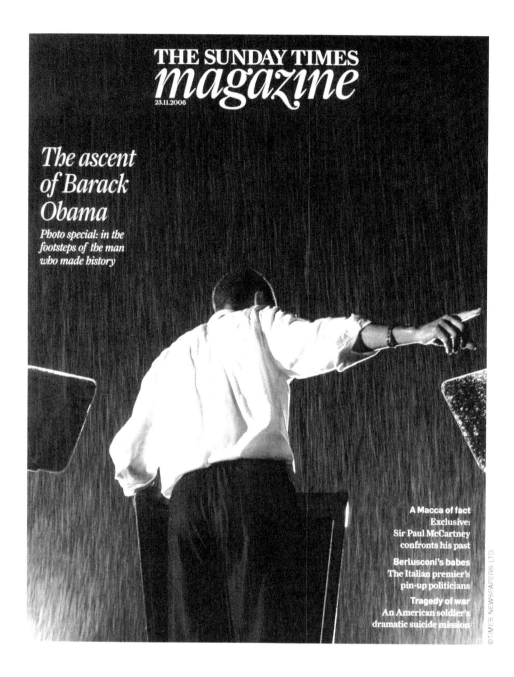

THE SUNDAY TIMES MAGAZINE, NOVEMBER 23, 2009
TIME, MARCH 10, 2008

These covers focus on Barack Obama from the rear. *Time's* execution features a photograph of the back of the president's head, positioned in front of a bright stage light. The atmospheric composition is reminiscent of an eclipse of the sun. Obama's detractors may have also seen a negative metaphor in here — that of a dark force blotting out the light.

By contrast, Britain's *Sunday Times Magazine* uses an image of the Senator speaking at a campaign rally in Fredericksburg, Virginia, on September 2008. As he addresses the crowd in the midst of the pouring rain, photographer Callie Shell shoots upward from a slight angle, capturing the back of his head and body against the backdrop of an atmospheric sky.

Both executions buck the conventions of magazine cover design that rule against showing the back of a subject's head on a front page. But since he first exploded onto the political scene, Obama's rear image — the most recognisable African American example since Mike Tyson — has become as identifiable as his front.

The New York Times Magazine

JANUARY 18, 2009

OBAMA'S PEOPLE

PHOTOGRAPHS BY NADAV KANDER

Prospect

DECEMBER 2008

POLITICS
ESSAYS
ARGUMENT

HOPING FOR AUDACITY

Can Obama revive American liberalism?

By Michael Lind

CULTURE AND RECESSION
Mark Lawson

SOCIALLY MOBILE BRITAIN
David Goodhart & Toby Young

A CRUNCH CAUSED BY LOW WAGES
Gerald Holtham

In this issue:

BEN LEWIS & JONATHAN FORD
Pop goes contemporary art

RICHARD BARRY
The windmills of my electricity bill

TIM BUTCHER
on China in the Congo

PETER OBORNE
Dave Cameron the radical

EDWARD CHANCELLOR
The cult of Milton Friedman

CHRISTOPHER DE BELLAIGUE
Why Iranians always blame the Brits

FICTION
by Hassan Blasim

REFLECTIONS ON OBAMA
from Martin Walker, Thomas Wright, Jonathan Derbyshire and James Crabtree

se covers from *The New York Times Magazine* utilise verful graphic devices in place of photography. The ruary 2009 edition, by Philadelphia-based design studio : Heads Of State, offers an original illustration of the lead ry about what President Obama planned to do to fix the ion's flagging economy. The execution uses the metaphor of .ny figure of Obama attempting to wallpaper an oversized merican flag as it threatens to peel away from a wall and zulf him. The detail of the image is powerfully simple, yet efully crafted — note how the stem of the wallpaper roller pears to be too short for the president to actually reach the of the canvas. The implication is clear — that however hard tries he may never fix the problem of America's economy.

There was a point during the run up to the 2008 presidential election when editors at *The New York Times* were confident that Obama would win. In anticipation of this fact they commissioned photographer Nadav Kander to shoot 52 portraits of members of Obama's administration, for its planned inaugural edition. The series was the largest collection of images by a single photographer ever to be published in the newspaper. For the cover design the magazine's editors cleverly resisted the temptation to show any photography from Kander's folio inside, instead making use of heavy black typography rendered on a stark white background. The resulting graphic entices the reader to explore what lies beyond the first page.

This cover makes use of Barack Obama's distinctive profile. t shows the Democratic presidential nominee speaking it his final campaign rally before Election Day, at Prince William County Fair in Manassas, Virginia, on November 3, 2008. Earlier that same day Obama's grandmother Madelyn

Dunham died of cancer, aged 86. The photograph, shot by Joe Raedle, captured Obama mid-flow during his speech, with his mouth open and his eyelids blinking, making him appear as if he is actually praying.

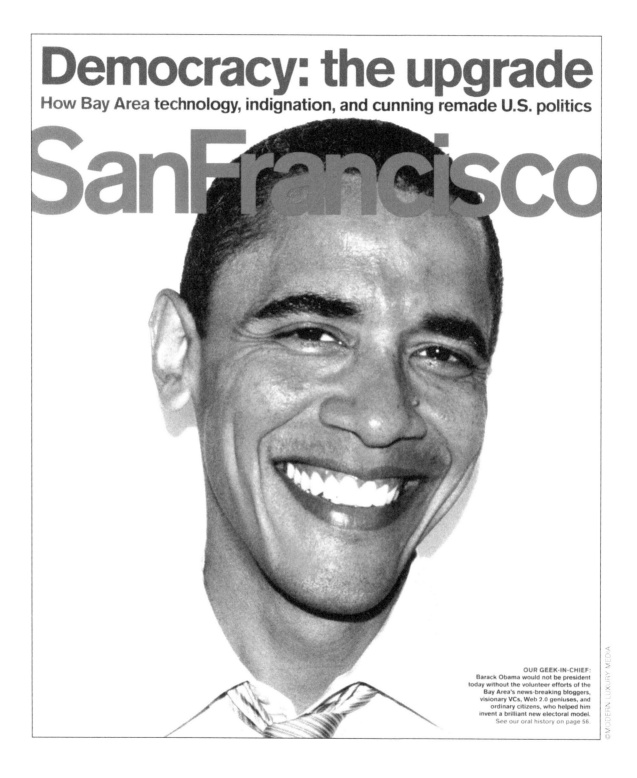

Democracy: the upgrade

How Bay Area technology, indignation, and cunning remade U.S. politics

SanFrancisco

OUR GEEK-IN-CHIEF:
Barack Obama would not be president today without the volunteer efforts of the Bay Area's news-breaking bloggers, visionary VCs, Web 2.0 geniuses, and ordinary citizens, who helped him invent a brilliant new electoral model.
See our oral history on page 56.

©MODERN LUXURY MEDIA

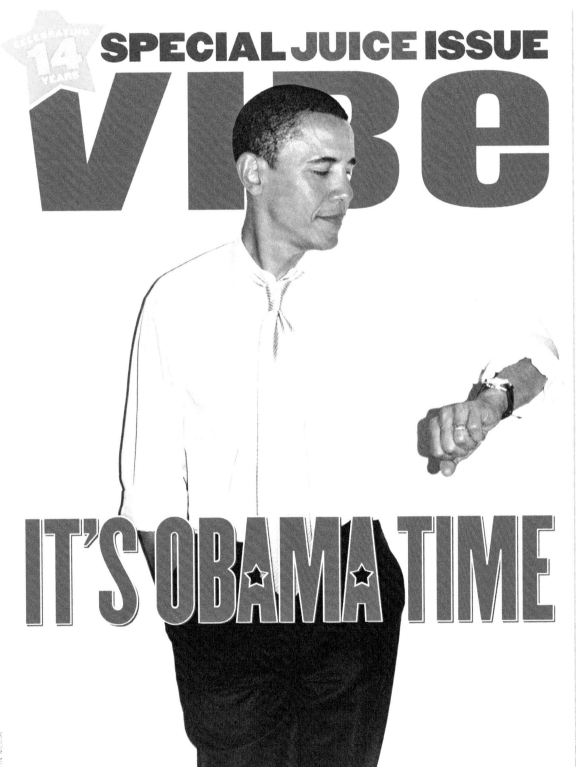

SPECIAL JUICE ISSUE

VIBE

CELEBRATING 14 YEARS

IT'S OBAMA TIME

©SPIN MEDIA

These photographs formed part of a series shot for hip-hop monthly *Vibe*'s annual "juice" issue. The images, by fashion photographer Terry Richardson, were taken at the Hart Senate Office Building, Washington DC, on June 20, 2007, just months after Obama has secured the Democratic nomination to run for president. The magazine's choice of photographer would later raise eyebrows, as Richardson — whose work has been referred to as "porn chic" — was accused in 2010 of indulging in inappropriate sexual behaviour with some of the young models on his fashion shoots.

The *Vibe* cover image selected for its September 2007 edition shows Obama in relaxed mode — jacket off, tie loosened, one hand in his pocket. It's a clean design on a classic white background, with minimal cover lines. Richardson and the *Vibe* editors persuaded Obama to look at his watch in order to create the ensuing headline. In March of 2009 a signed copy of this edition sold on eBay for $1,000.

San Francisco magazine opted for an Obama headshot from Richardson's series for the cover of their February 2009 edition. The portrait is striking in capturing Obama looking relaxed, youthful, happy and handsome. But this photograph was taken before he was elected president. After this, once the pressures of office had taken their toll, he would never look this youthful again.

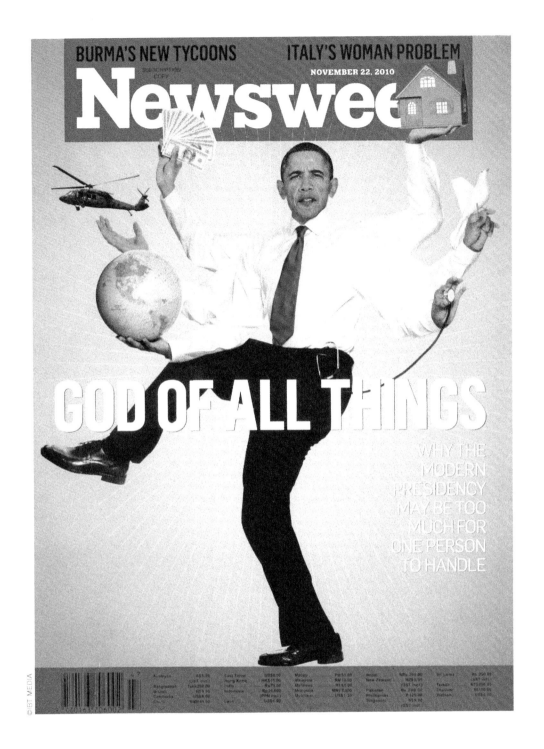

NEWSWEEK, NOVEMBER 22, 2010

This *Newsweek* cover depicts Obama as the Hindu deity Lord Shiva, alongside the headline "God Of All Things". The president is presented as the six-armed sacred figure, juggling a multitude of complex problems and policy issues that go along with the job of being president of the United States, all while perched on one leg. The rendering irked some Hindus, who felt that Shiva — one of three pre-eminent gods within Hinduism, along with Brahma and Vishnu — was being disrespected by the magazine. "Hinduism's sacred images are too often appropriated in popular culture without understanding their spiritual relevance to Hindus," said Suhag Shukla, managing director of the Hindu-American Foundation, on FoxNews.com. "For Hindus, the iconography gives insight into the divine realm, and each aspect of representation is replete with profound symbolism that is lost and even debased by such attempts at humour."

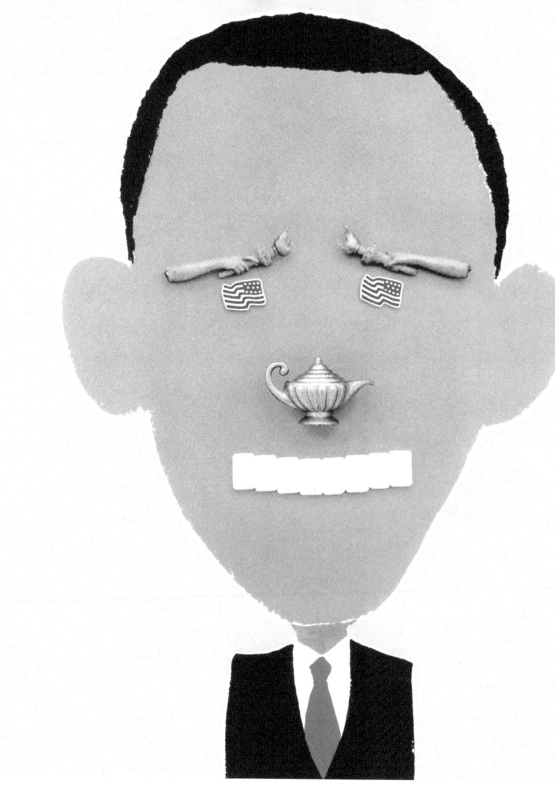

BARACK OBAMA BY PIVEN

Esquire

THE MAGAZINE FOR MEN WHO MEAN BUSINESS

FEBRUARY 2009 | £4.25

piven

Where the Storm Never Ends:

Survivalism in the Rockaways
p.32

Also: Arthur Sulzberger Jr. Can't Catch a Break **p.8** / The Two Defining Weeks of Michael Bloomberg **p.42**

+Sally Field Sobs for History p.67 / **The Year's Most Radical Parenting Book** p.74

NEW YORK

NOVEMBER 19, 2012

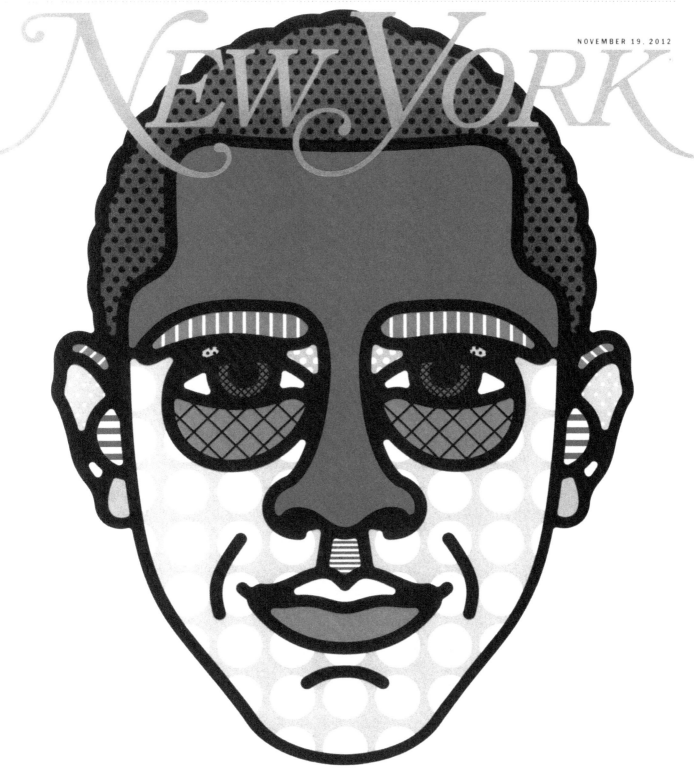

44's Next 4, **by John Heilemann**
The Say-Anything Election, **by Frank Rich**
V-Day for the Class War, **by Jonathan Chait**
Mitt Romney, With Sympathy, **by Benjamin Wallace-Wells**

These cover treatments use original graphic devices to rework the Obama aesthetic. Illustrator Craig Redman's cartoon-style cover for *New York* magazine celebrated Obama's 2012 re-election victory. His bold use of geometric shapes, day-glo block colours and exaggerated facial features make this one of the standout covers of the Obama era. The final image resembles a giant sticker, crying out to be peeled and stuck to a window or a suitcase. Despite the fact that the composition is not instantly recognisable as President Obama, the magazine's editors resisted the temptation to use prominent cover lines to add exposition, leaving the finished artwork free of clutter, with just four tiny lines of text positioned subtly underneath the subject's chin.

Illustrator and caricaturist Hanoch Piven marked Obama's 2008 election victory with his own alternative rendition for *Esquire*'s UK edition. This ingenious cover was commissioned as a limited edition for the magazine's subscribers, and features the newly elected president as a child-like collage of elements arranged against a blue backdrop. The artist utilises powerful American iconographic symbols in the form of two badges (featuring the US flag) for Obama's eyes, with the arms of New York's Statue of Liberty for his eyebrows. The Stars and Stripes on the badges are distorted, subtly referencing the problems and imperfections of the country Obama is about to preside over. Meanwhile, the president's nose is depicted as Aladdin's lamp, both a reference to his perceived exoticism, and a cypher for the expectation that he will pull off feats of magic as the first outsider to make it to the White House. The ensemble is finished with more Americana, in the form of a line of white chewing gum pieces for Obama's mouth, suggesting that he may in the end get stuck for things to say, or indeed that his objectives may get stalled. The image is rendered completely without cover lines, the final image saying all it needs to.

FORTUNE, NOVEMBER 9, 2009

The brief for this playful cover for *Fortune* magazine's lead feature, "Obama & Google: A Love Story", was to illustrate what was perceived as the particularly close relationship between the two parties. The image began as a formal portrait of the president, taken by Ben Baker, which was then re-touched, inserting the "oo" letters from within the tech giant's logo. The artwork took 36 hours of retouching by the wizards at New York's Splashlight studio to create the illusion of the coloured spectacles, and to make them appear natural — as if the president really is seeing the world through Google's lens.

STEVE RATTNER'S
INSIDE ACCOUNT OF THE
AUTO BAILOUT. PAGE 55

40 UNDER 40
THE YOUNG GUNS WHO ARE ROCKING
THE BUSINESS WORLD. PAGE 74

THE TWISTED TALE OF
MICHAEL JACKSON'S
MILLIONS. PAGE 114

FORTUNE

Obama & Google:
A Love Story

**THE PRESIDENT
AND THE
TECH GIANT
SEE EYE-TO-EYE
ON ALMOST
EVERYTHING...**

**IS THAT A
GOOD THING?**

BY JIA LYNN YANG
AND NINA EASTON
PAGE 104

19 JANUARY 2009/£2.95

NEWSTATESMAN

www.newstatesman.com | Britain's award-winning current affairs weekly

Obama
What the world expects...

By Will Hutton, Sigrid Rausing,
Alec MacGillis and Mark Lynas

Martin Bright
We need a New Deal
for the mind

Jon Cruddas
My colleagues don't know
what they're doing

Plus: British forces
and foreign policy
A round-table report

AUSTRALIA A$7.20
CANADA C$5.95
NEW ZEALAND NZ$10.50
USA US$5.50

EURO ZONE €4.90
(EXCL. GREECE & PORTUGAL)
GREECE €4.60
PORTUGAL (CONT.) €4.90

9 771364 743124 04 >

© THE NEW STATESMAN LTD

THE NEW STATESMAN, JANUARY 19, 2009
THE GUARDIAN WEEKEND, DECEMBER 27, 2008

Few magazine covers still make use of dramatically cropped photography to create strong visual narratives. *The New Statesman* took the unusual step of not showing Obama's face on this post-election cover of 2009. Instead they created a focal point around the play of his mouth and hands in a photograph taken mid-speech, while the senator was out on the campaign trail. The clenched hands convey the emotion of the set piece, suggesting sincerity, determination and passion.

By contrast, the front page of Britain's *The Guardian* newspaper's supplement, *Weekend*, takes the opposite stance. Published just after his 2008 victory, it shows Obama's head, but nothing else, set against an expanse of blue sky and pressed into the corner of the frame, where it rests upon the baseline of the magazine's border. With all context removed from the composition, all we are left to focus on is the celebratory smile of a happy man.

'They said this
day would
never come...'

©GUARDIAN MEDIA GROUP

ToyFare (closed in 2011) was a monthly magazine for toy enthusiasts published by Wizard Entertainment. It focused on vintage collectables, as well as previewing new and upcoming products. This amusing cover features Barack Obama in a spoof of the famous scene from *Star Wars: Episode IV – A New Hope*, in which R2-D2 projects a holographic message from Princess Leia to Obi Wan Kenobi, asking for his help in the struggle against the Empire. A well-dressed plastic Obama figurine plays the Obi Wan figure, set against the backdrop of a barren desert landscape.

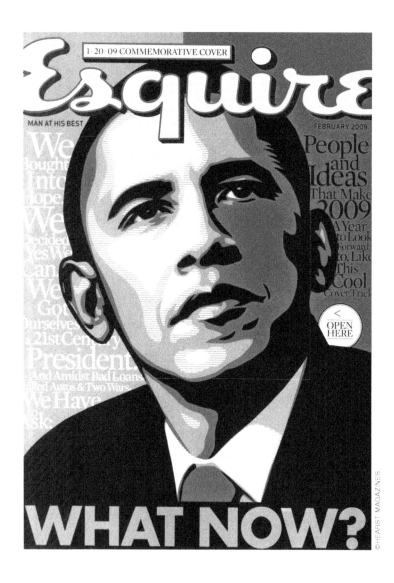

In the image: 1/20/09 COMMEMORATIVE COVER · Esquire · MAN AT HIS BEST · FEBRUARY 2009 · We Bought Into Hope. We Decided Yes We Can. We Got Ourselves a 21st Century President. And Amidst Bad Loans, Failed Autos & Two Wars. We Have To Ask. · People and Ideas That Make 2009 A Year to Look Forward to. Like This Cool Cover Trick · OPEN HERE · WHAT NOW? · ©HEARST MAGAZINES

ESQUIRE, FEBRUARY 2009
L'UOMO VOGUE, NOVEMBER 2009

These executions feature the work of Los Angeles-based street artist and graphic designer Shepard Fairey, who rose to fame during Obama's 2008 election campaign with his Andy Warhol-inspired, colourised graphic portrait of the senator. Adorned with the slogan "HOPE", the image popped up everywhere — not just on posters, but stencilled on walls, skateboards, lamp posts and pavements — quickly acquiring iconic status amongst the public and the media alike. Peter Schjeldahl, writing in *The New Yorker*, called it "the most efficacious American political illustration since 'Uncle Sam Wants You."

But Fairey's guerrilla art somehow wouldn't be credible if it didn't lead to trouble with the establishment. This took the form of legal action by the Associated Press (AP), which actually owned the copyright to the photograph of Obama — taken at a National Press Club event in 2006 —

that Fairey used to create his poster. AP claimed copyright infringement, while the artist exerted his rights to the image under the doctrine of "fair use". Regardless, the poster was widely adopted on the covers of many magazines during 2008 and 2009, most of which replaced Fairey's original "HOPE" slogan with other post-election revisions, such as "NOPE", "DOPE", "HATE" or in the case of the *Esquire* cover featured here, "WHAT NOW?"

L'Uomo Vogue's cover, photographed by Francesco Carrozzini, features Fairey himself lying beneath the poster that made his name, his eyes closed, and with his famous graphic dominating the frame of the front page. The magazine's artwork — using similar typography and colouring to Fairey's design — forcefully superimposes itself over the top of his poster, allowing us to read both visual narratives simultaneously.

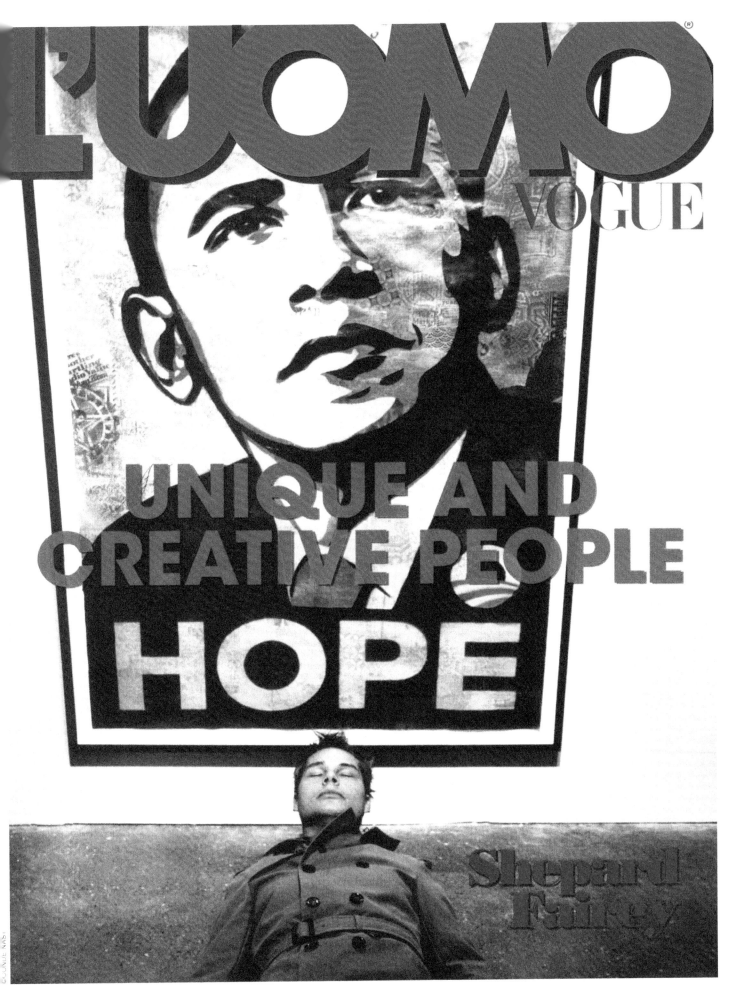

UPTOWN

LUXURY, LIFESTYLE & LIVING

IN BARACK WE TRUST
44
SPECIAL EDITION
WWW.UPTOWNLIFE.NET

THE ART OF OBAMA

FEBRUARY/MARCH 09 Nº19
WWW.UPTOWNLIFE.NET

©UPTOWN MAGAZINE

OBAMA
MANIA!

THE BARACK BUZZ:
*16 Windy City
People, Places and
Things That Will Rock DC!*

Obama Art: The Next Big Thing?

*What the World Really
Thinks of Chicago*

*Inauguration Special:
10 Washington Hotspots*

+PLUS

OUR HEALTH & BEAUTY
BLOWOUT: THE HOTTEST
NEW WORKOUTS, BEST NEW
SPAS, TRENDIEST TREATMENTS
AND TOP 10 PRODUCTS OF 2009!

These covers present a distinctive counterpoint to the photographic executions used by most of the publications that covered Obama's rise. Chicago-based luxury lifestyle magazine *CS* presents an illustration of the president in which his image, viewed from below, is shot through with energetic swathes of the colours of the Stars and Stripes

African American lifestyle title *Uptown* presented three different graphic covers for their special collector's issue of 2009. This featured example was created by Mexican-born illustrator and artist Rafael López. The cover story, "The Art Of Obama", discussed the popularity of art and artists inspired by the senator and his historic campaign. "Obama's image has become the presidential product everyone wants to possess and create," said article author Michael A. Gonzales at the time. "He is like Bono, Jay-Z and Che Guevara wrapped into one perfect package."

AMBASSADOR, NOVEMBER 2008

Detroit-based culture and lifestyle magazine, *Ambassador*, (opposite) features a portrait painting by Los Angeles-based Korean American artist David Choe for its rendering of Obama's profile — his densely textured and colourised head gazing downwards in deep contemplation. The word "HOPE", rendered above him, can just be seen below the magazine's title typography. Choe, who has also designed artwork for recording artists Jay-Z and Linkin Park, created two Obama portraits as part of a street art campaign that coincided with Shepard Fairey's famous poster during the build up to the 2008 election. Choe's painting eventually found its way into the White House, where it was hung on the wall following Obama's victory.

ambassador
COMMEMORATIVE EDITION

AND THE WINNER IS...
DETROIT'S NEXT TOP MODEL

WINNERS AND
FANFARE
2008 RED SEAL AWARDS

PHOTOGRAPHY
ARCHITECTURE
SCULPTURE
ART IN DETROIT

DR. DONNA ROCKWELL ON THE SIGNIFICANCE OF
PRESIDENT BARACK OBAMA

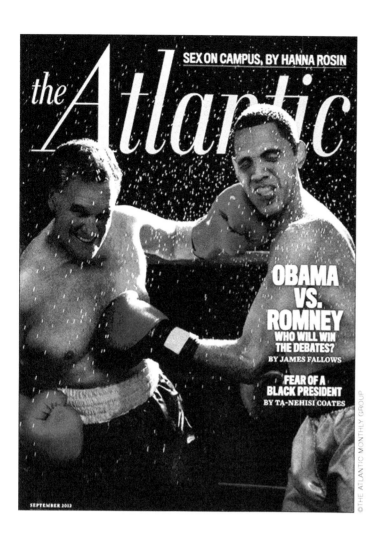

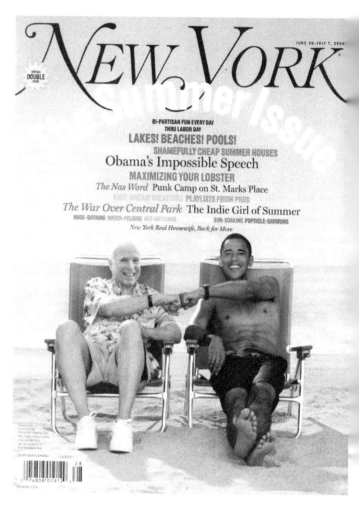

THE ATLANTIC, SEPTEMBER 2012
NEW YORK, JUNE 30 - JULY 7, 2008
TIME, OCTOBER 15, 2012

These covers offer different perspectives on Barack Obama's face-offs against Republican challengers during his two election campaigns. The September 2012 cover of *The Atlantic* features Obama and Mitt Romney as two boxers slugging it out in an imaginary title bout. The image was shot using look-a-likes at Gleason's gym in Dumbo, New York — the same spot where boxing legends Jake LaMotta, Mike Tyson and the late Muhammad Ali used to train. The expressions on the faces of the re-touched figures are surprisingly realistic, complete with sprays of sweat as Romney lands a left squarely on Obama's cheek.

New York magazine's 2008 summer edition offered a humorous and well-crafted montage of Senator Obama and his 2008 Republican rival John McCain relaxing on deck chairs at the beach. The photo-illustration, by photographer Andrew Eccles, portrays the pair not as adversaries, but as buddies taking much needed time off from the pressures of the campaign trail to chill out together. The smiling partners cement their temporary "bromance" with an obligatory "fist-bump".

Time's cover focuses on the 2012 confrontation between Obama and Romney. The powerful graphic depicts an intense face-off between the two contenders, in which their profiles are densely laced with white and grey text. The result is like a hyped up form of Tā moko — the traditional form of Māori face tattoo.

In 2009 businessman, politician and philanthropist Michael Bloomberg purchased an ailing magazine called *Businessweek*. He renamed it *Bloomberg Businessweek*, headhunted a new creative team from *Time* magazine and Britain's *The Guardian* newspaper, and transformed the once moribund title into a powerhouse of creativity and editorial innovation.

The magazine's front covers became the focal point of the publication's radical new direction. One of the best is this unique example from their November 2013 edition. Conceived by creative director Richard Turley, the image mimics a computer screen with a poor Internet connection, in which a partial image of Barack Obama's face struggles to load, while the screen's timer whirrs around endlessly in frustration. At first sight the finished artwork — with its white space and chopped image — looks like a printing error, until one looks more closely for the creative reveal. It is a clever accompaniment to the issue's lead feature about Obama's second term in office needing a "reboot", and a brilliant example of the use of print to illustrate a digital concept.

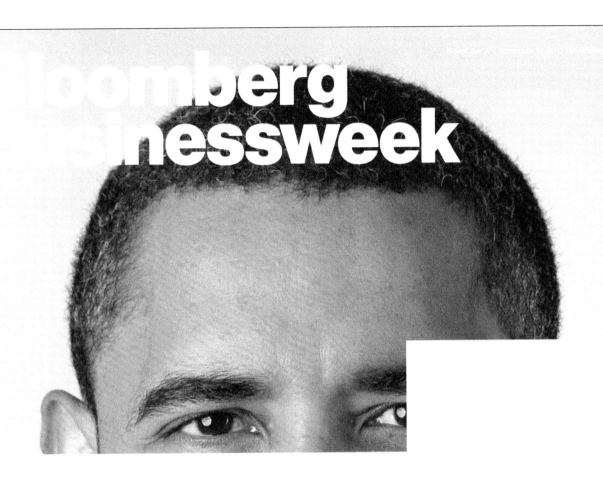

Bloomberg
Businessweek

Crashed
One year—and one
epic fail—into his second
term, Barack Obama
needs a reboot p14

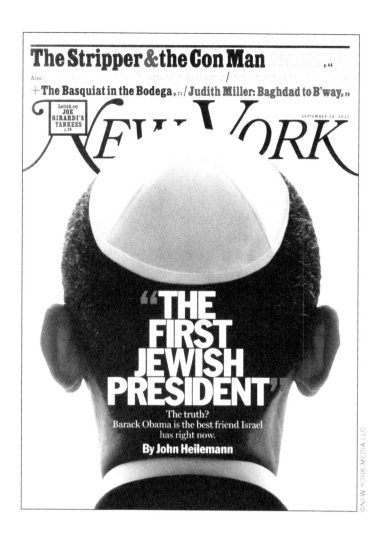

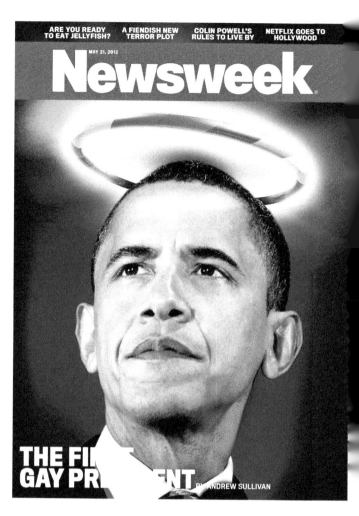

NEW YORK, SEPTEMBER 18, 2011
NEWSWEEK, MAY 13, 2012
OUT, DECEMBER 2015

These covers play on the idea that Obama's opinions, values and actions reflect those that would be expected of a Jewish or a gay president. This metaphor was first applied to President Bill Clinton in a 1998 *New Yorker* article by the novelist Toni Morrison, who said of him, that "white skin notwithstanding, this is our first black president." She argued that what made him "black" was the fact that he had lived a life similar to that of many African American men.

It was during Obama's presidency that this metaphor evolved further. Aside from the examples noted here, in 2008 he was also labelled "the first woman president", by *Newsweek*'s Martin Linsky, and in 2009 the Associated Press asked if he was the first Asian American president.

The cover of *New York* magazine's edition of September

18, 2011 depicts the back of Obama's head, adorned with a Jewish skullcap (known in Hebrew as a kippah or in Yiddish as a yarmulke). The cover line, "The First Jewish President", previews the lead story by John Heilemann, which contended that "Barack Obama is the best thing Israel has going for it right now".

The *Newsweek* cover shows Obama with a rainbow-coloured halo hovering above his head like a Frisbee. During his tenure his support for same-sex relationships transformed him into an icon and hero for the lesbian, gay, bisexual and transgender (LGBT) community. *Out*, a leading LGBT magazine, voted him Ally of the Year in their December 2015 edition. He became the first sitting president in history to pose specially for the cover of such a title.

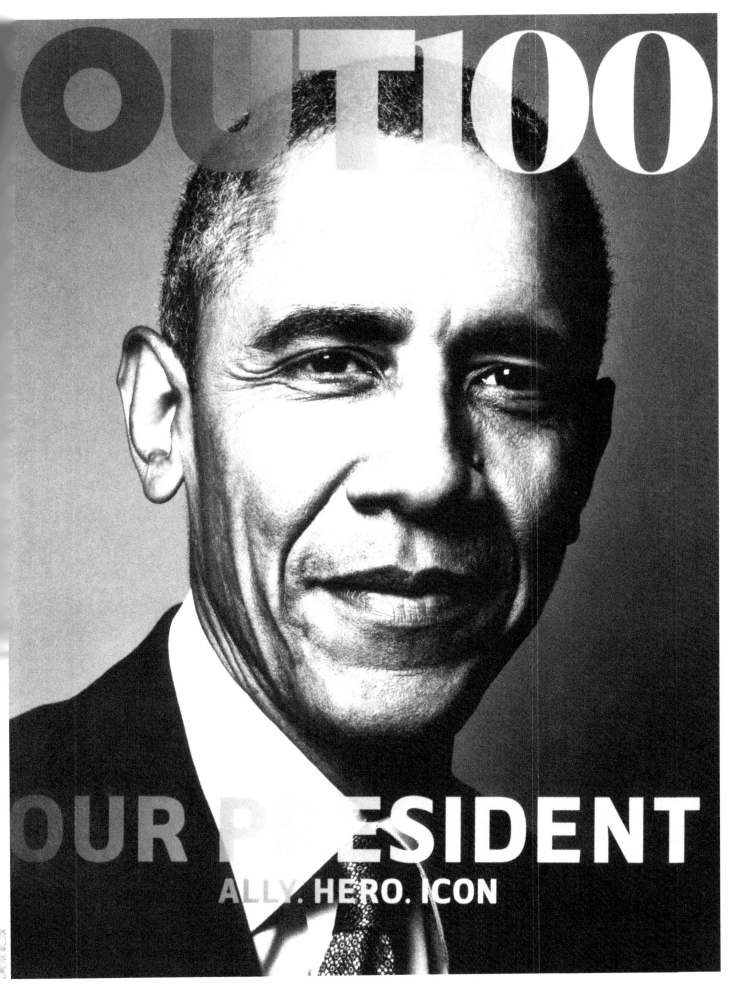

OUT100

OUR PRESIDENT

ALLY. HERO. ICON

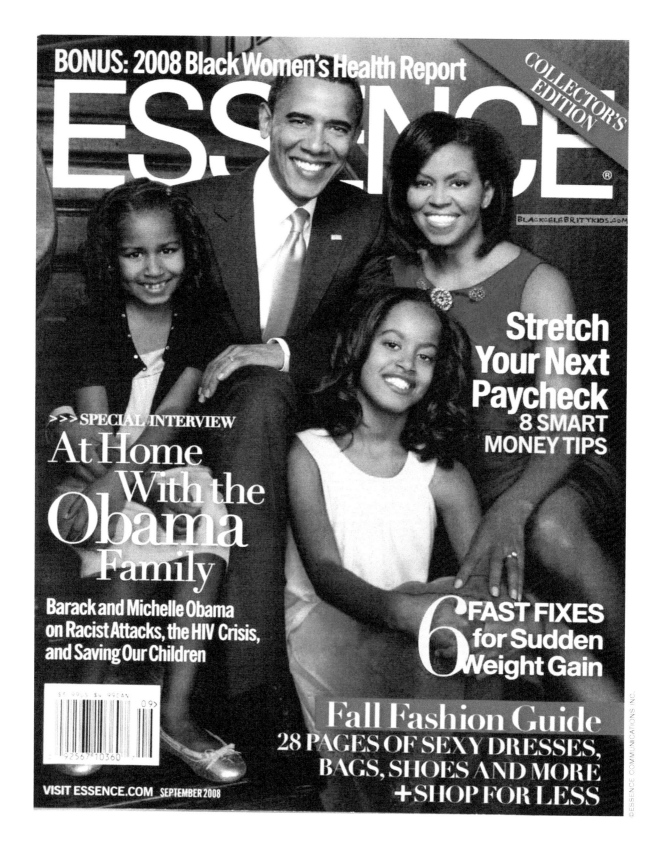

ESSENCE, SEPTEMBER 2008
THE TIMES MAGAZINE, AUGUST 16, 2008

No presidential hopeful can succeed without presenting a strong set of family values to the voting public, and these covers, published just a few weeks before Obama's 2008 election victory, feature images of his wife Michelle and daughters Malia and Sasha. Collectively the Obamas have done more to boost the image of the prosperous middle-class African American family than any other group in the history of modern America.

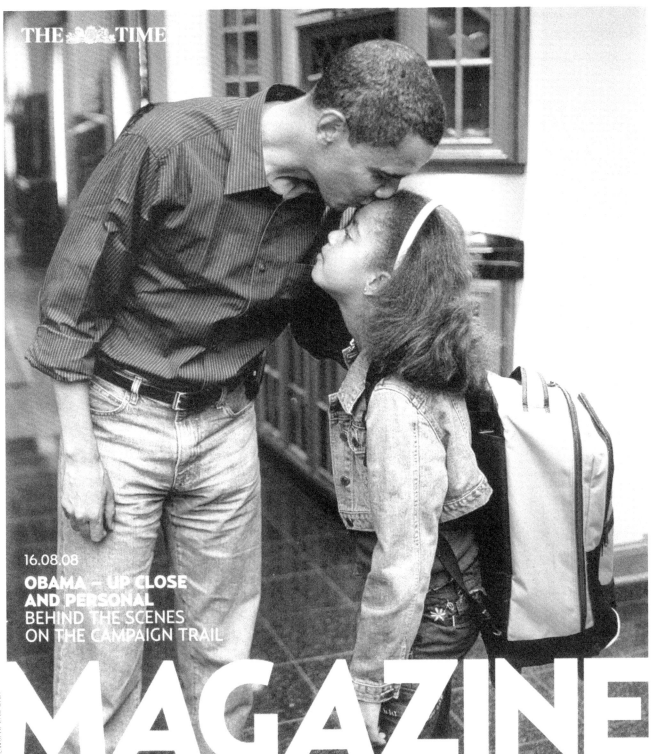

THE TIMES

16.08.08

**OBAMA – UP CLOSE
AND PERSONAL**
BEHIND THE SCENES
ON THE CAMPAIGN TRAIL

MAGAZINE

PLUS JULIETTE BINOCHE GETS METAPHYSICAL ★ TIPS FOR MOTHERS OF THE BRIDE

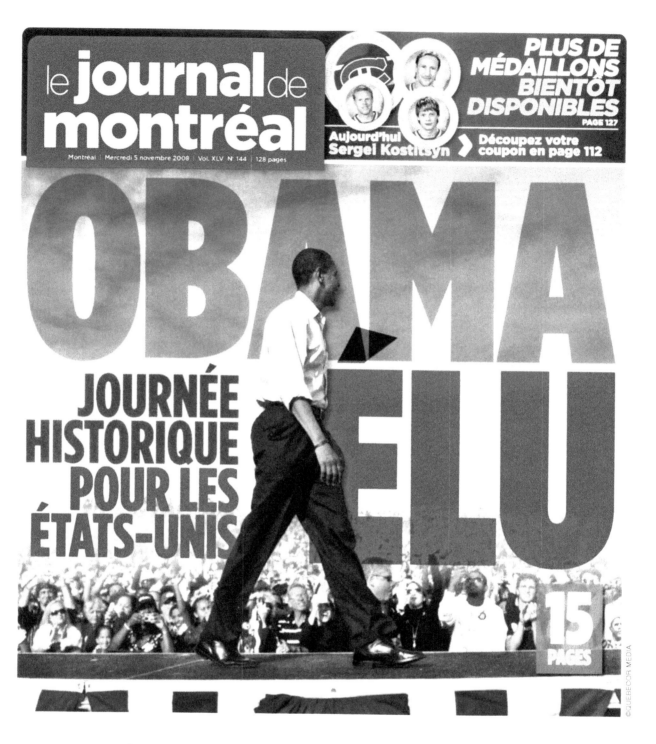

LE JOURNAL DE MONTRÉAL, NOVEMBER 5, 2008
ESQUIRE, JUNE 2008

Here are two clever interactions between typography and photography. *Le Journal de Montréal* creates the illusion that Obama is actually striding through a curtain of colourful, giant-sized cover lines as an enthusiastic crowd look on. The text is so inextricably entwined with the image that it becomes a part of the audience, the sky and the man himself.

The American edition of *Esquire* is known for its signature cover style that threads its headline typography behind the subject image. In this execution Senator Obama stands proudly in front of his own billboard-style rendering, which reads "Ready, Set, Obama". The senator's frame deliberately obscures a portion of the lettering, but the super-sized type, which challenges the photograph for dominance, means that it hardly matters.

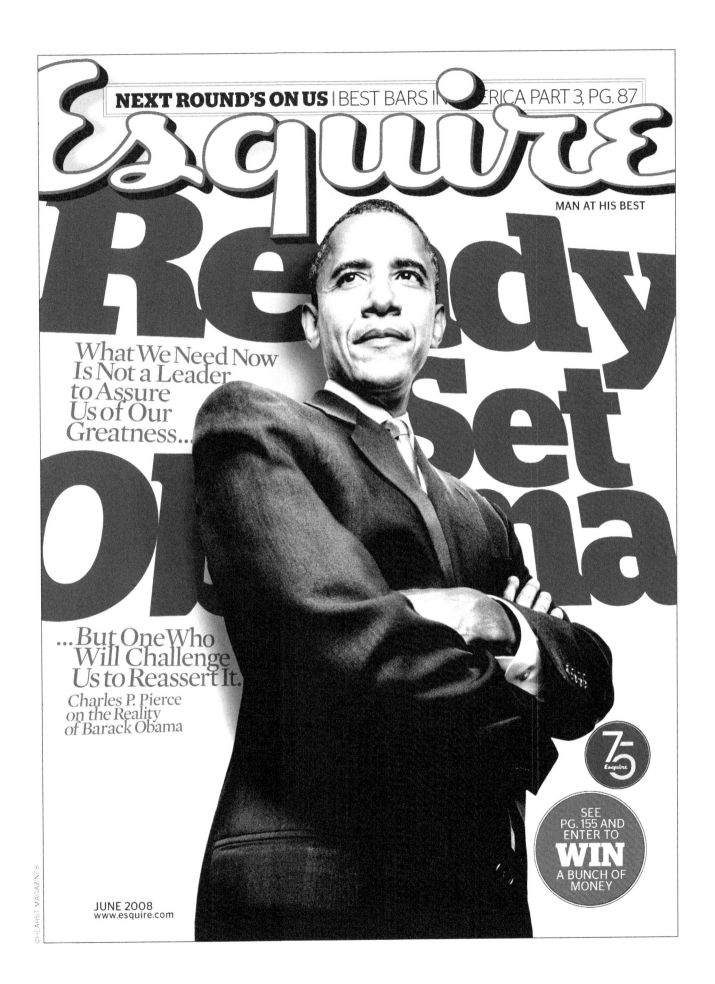

NEXT ROUND'S ON US | BEST BARS IN AMERICA PART 3, PG. 87

Esquire

MAN AT HIS BEST

Ready
Set
Obama

What We Need Now
Is Not a Leader
to Assure
Us of Our
Greatness...

...But One Who
Will Challenge
Us to Reassert It.
Charles P. Pierce
on the Reality
of Barack Obama

75
Esquire

SEE
PG. 155 AND
ENTER TO
WIN
A BUNCH OF
MONEY

JUNE 2008
www.esquire.com

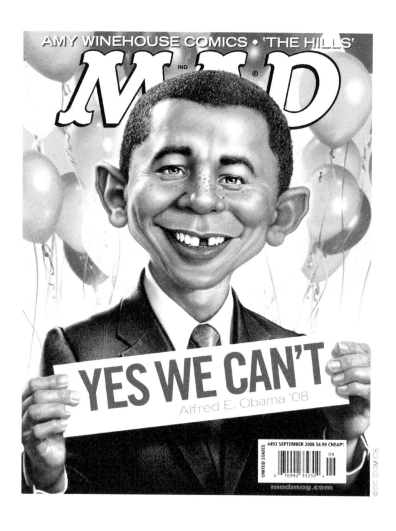

MAD, SEPTEMBER 2008/FEBRUARY 2012

Here are two of Obama's most amusing covers, from *Mad* magazine. The September 2008 edition of the quarterly satirical title was the first to feature the statesman, with the headline "Yes We Can't". Voted number 10 in *Time*'s top 10 magazine covers of 2008, this execution features the magazine's fictional mascot, Alfred E. Neuman, as a goofy caricature of the presidential candidate.

The cover of *Mad*'s February 2012 edition mimics the cover of *Nevermind*, the classic album by Nirvana, the American rock band fronted by the late Kurt Cobain. The album's iconic image of the naked baby floating in the water, attempting to catch a dollar bill attached to a fishhook, is copied almost exactly, with the addition of Obama's head superimposed onto the infant's body. The unsettling image was inspired by the US debt crisis of 2011, when Democrats and Republicans were locked in disagreement over whether or not to raise the legal limit on its debt, thereby potentially leading to the country running out of money.

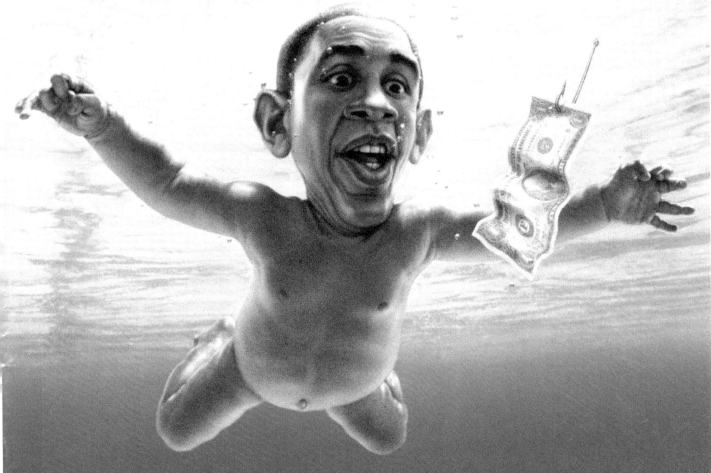

The

20 DUMBEST

People, Events, and Things **2011**

#513 FEBRUARY 2012 $5.99 CHEAP!

US / CANADA

02

TheIdiotical.com

(THE YEAR WE RAN OUT OF MONEY!)

©LIBERTY MEDIA FOR WOMEN LLC

MS, WINTER 2009
THE NEW STATESMAN, AUGUST 3, 2009

Here are two of many examples of covers depicting President Obama as characters from history and popular culture. Women's title, *Ms*, featured the president-elect as a Superman-style feminist icon, ripping his shirt open like the popular superhero, revealing a costume adorned with the phrase, "This Is What A Feminist Looks Like". The artwork, by illustrator Tim O'Brien, was one of a number of front pages that positioned Obama, not as president, but as saviour, keying

into the public fantasy about his superhuman capabilities. By contrast, the cover of *The New Statesman* rendered Barack Obama as the black Julius Caesar, the famous Roman emperor, complete with laurel wreath — the crown of victory — wrapped around his head. The artwork, by illustrator Josie Jammet, fuses illustration and photography, depicting the commander-in-chief staring into the distance as if he's surveying all the military might within his fleet.

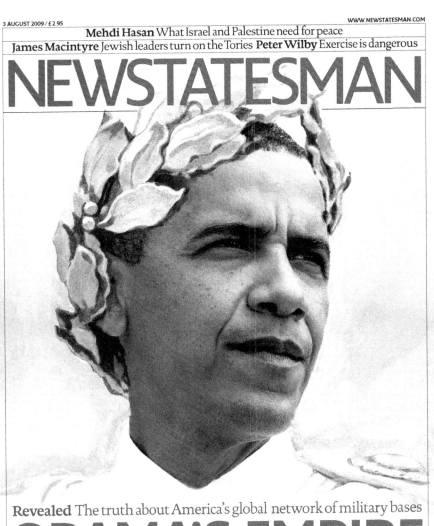

3 AUGUST 2009 / £2.95

WWW.NEWSTATESMAN.COM

Mehdi Hasan What Israel and Palestine need for peace
James Macintyre Jewish leaders turn on the Tories **Peter Wilby** Exercise is dangerous

NEWSTATESMAN

Revealed The truth about America's global network of military bases

OBAMA'S EMPIRE

AUSTRALIA A$7.20
CANADA C$5.95
NEW ZEALAND NZ$10.50
USA US$5.50

EURO ZONE €4.90
(EXCL. GREECE & PORTUGAL)
GREECE €4.60
PORTUGAL (CONT.) €4.90

©THE NEW STATESMAN LTD

The
Economist

Nanotechnology and cancer
Don't expand Heathrow
The charm of big cities
A green New Deal?
In defence of credit-default swaps

NOVEMBER 8TH–14TH 2008 www.economist.com

Great expectations

£4.00

The
Economist

World trade shrivels
Don't leave Afghanistan
Geithner's half-plan
In praise of the Nano
The joy of work

MARCH 28TH– APRIL 3RD 2009 Economist.com

Learning the
hard way

©THE ECONOMIST NEWSPAPER LTD.

INSIDE: A 14-PAGE SPECIAL REPORT ON AMERICA'S FOREIGN POLICY

The Economist

Freeports: where the rich hide their stuff
Nokia reinvents itself–again
Fighting over Fannie and Freddie
The danger of Balkanised banks
Simplicity in business: it's complicated

NOVEMBER 23RD–29TH 2013 Economist.com

The man who used to walk on water

US$7.99 · C$7.99

THE ECONOMIST, NOVEMBER 08, 2008; MARCH 23, 2009; NOVEMBER 23-29, 2013

The disappointment was inevitable. Like a Shakespeare play, these covers, in three acts, tell the story of Obama's slide from the lofty pedestal of his historic 2008 victory. The first (far left), captures the excitement and euphoria of that moment, with the new president framed amidst a flurry of blurry American flags. The cover line, "Great Expectations", acts as a foreboding prelude to the choppy waters ahead. The second cover, released barely four months later, shows President Obama looking worried as he begins to come to terms with the harsh realities and frustrations of office. It is presented in classic *Economist* style, with the image rendered on a white background together with the sobering headline — "Learning the hard way" — in bold black type, bearing down ominously over Obama's head. The third cover, four years on, completes the narrative of the president's slide, with Obama depicted as the fallen messiah who once walked on water, but is now sadly sinking beneath it, merely mortal.

It was during the build-up to the 2008 presidential election that Senator Barack Obama was first cast by the American media as "black Superman" — a post-modern Marvel Comics-style superhero in spandex, poised to save America, and the world. The joke was, many people actually thought he could. In similar fashion to the way misguided TV and film viewers mistake an actor's role in a movie for that of the person's real life, many people overdosed on Obama's fantasy persona, as opposed to the real man and his human frailties.

Was it racist for the press to depict Obama as Superman, the Messiah, the black Jesus? Some would say no, because that is simply how he presented himself to the 2008 electorate — as a transformative figure who would fix everything, who would bring change, possibly even revolution. But then again, every other president in the history of America has promised the same thing. George Bush also used the rhetoric of change when he was electioneering, but the press chose not to depict him as Batman, or a flying demi-God in crimson underpants. So why do it to Obama? Why was there a different mode of presentation for a black presidential candidate than there was for a white one? This is where race enters. Because Obama is black, and he was the *first* president to be black, people's expectations were different. Higher.

Historically, the first pioneering African American achievers within their respective fields have come burdened with extreme expectations from both blacks and whites — think the debut of 1940s baseball star Jackie Robinson for example — while their more ubiquitous white contemporaries have enjoyed the freedom to be mediocre, or worse. It was African American comedian Chris Rock who summed it all up when he said, "Being the first black anything sucks."

In Obama's case, hopeful voters transplanted an inherent specialness onto his aesthetic as "the first black" — and so when he turned out not to be so extra special — when he turned out to be more "man" than "super-man" — many felt let down, while his opponents were gleeful. Obama himself saw this inevitable disappointment coming from very early on. "I serve as a blank screen on which people of vastly different political stripes project their own views," he wrote in his 2006 book, *The Audacity Of Hope*. "As such, I am bound to disappoint some, if not all of them."

The October 2012 cover of *The Spectator*, like the denouement of a disaster movie, skilfully captures Obama's unavoidable fall from grace as he headed toward his second term in office. The scene, a modern-day Shakespearean tragedy, features a cartoon of the president as a caped Superman figure caught in the midst of a fatal "kryptonite" moment. He tumbles helplessly out of the sky, his powers sapped, his body suddenly mortal, his face contorted with the shame of a failed Messiah.

In concocting the Obama superhero myth, the press set him up for the inevitable fall they knew would follow — but that is what they have always done to celebrities. Were their actions racist? To them it was just business, nothing more.

20 OCTOBER 2012 | £3.50

WWW.SPECTATOR.CO.UK | EST. 1828

THE SPECTATOR

Obama falls to earth

Harold Evans on the President's battle to recover his powers

Why I growl at dogs / China vs USA / Fascist art
Rod Liddle Thucydides Harry Mount

GIELGUD'S GREATEST MISSES

Fine Arts Special

HOW WOMEN WILL SAVE EUROPE

JANUARY 18, 2013

Newsweek.

INAUGURATION 2013

PULL FOR CONTENT

THE
SECOND COMING
AMERICA EXPECTS. CAN HE DELIVER?
BY EVAN THOMAS

©IBT MEDIA

As late as January 2013 there were still elements within the media that continued their fixation with Obama as "the messiah", despite the fact that this ill-chosen metaphor had all but dissipated elsewhere within the press after the fallout from the 2008 election. As Obama embarked upon his second term in office, *Newsweek* resurrected it with this cover image of the president in profile, looking in a forward direction as the challenge of his new term unfolded. The ensemble is finished with the provocative strapline, "The Second Coming". The tag would serve only to further raise the level of expectation heaped upon Obama to impossible heights. What effect will such portrayals have on those who will construct his legacy? Will he be judged as man, or as failed messiah?

Is this what Barack Obama will look like after eight tough years in office? *Bloomberg Businessweek*'s image — created during Obama's 2012 re-election campaign by editor Josh Tyrangiel and creative director Richard Turley (with Photoshop work by Justin Metz) — offers a clever comment on the personal cost of taking on the world's most difficult job. It depicts Obama as a prematurely aged old man, complete with grey hair, tired eyes and inverted smile. The original brief was to age both Obama and Republican challenger Mitt Romney by just four years — the length of the term in office — for separate covers. "We aged them too much really — deliberately," Turley confessed. "It needed to be a bit too much in order for them to look any different and for it to be a bit of a shock."

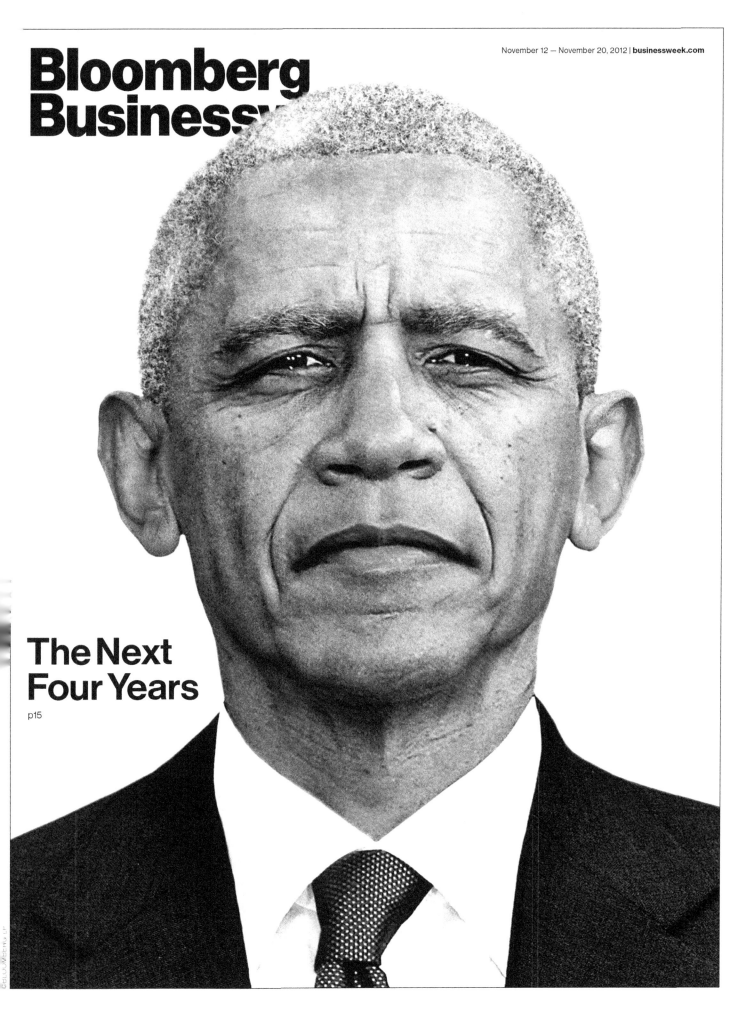

Bloomberg Businessw

The Next Four Years

p15

revie

Jonathan Raban

How did Obama's inaugural speech sl

BARACK
OBAMA,
PRAGMATIST
CHRISTOPHER HAYES

SIT-DOWN
IN CHICAGO

SEXUAL HYGIENE
IN DENVER

REBEL IN SEARCH
OF A CAUSE

THE OBSERVER REVIEW, JANUARY 24, 2009
THE NATION, DECEMBER 29, 2008

The Nation's Obama cover renders the president seemingly carved out of a rock face, like the latest addition to the presidential sculptures of George Washington, Thomas Jefferson, Theodore Roosevelt and Abraham Lincoln that sit proudly atop Mount Rushmore, in the Black Hills of South Dakota.

Designed by art director Gene Case and advertising creative Stephen Kling, the composition displays the president-elect's monolithic visage in heavily striated side profile, as if it's been carved by a sentient desert wind. Since this edition was first published, the "Obama for Rushmore" question has actually been debated. A 2015 poll by Rasmussen Reports claimed that 21 per cent of Democrats would like to see Obama join the illustrious group of presidents sometime in the future.

A month after *The Nation*'s cover, Britain's *Guardian* newspaper published their own "Obama Rushmore" image on the front of their *Review* section. The lead story, comparing Obama's inaugural speech with those of previous US presidents, shows his youthful visage flatteringly carved out of the rock face. Interestingly, his stony face is positioned slightly higher than those of the great names around him. The illustration, by John Morse, offers an alternative Mount Rushmore, featuring President John F. Kennedy amongst the heads, in place of George Washington, with Obama in the position currently occupied by Thomas Jefferson.

Rolling Stone captured President Obama on its cover during his visit to Kotzebue, Alaska in September 2015, as part of his campaign against climate change. The edition's cover lines are stripped away, focusing the viewer solely on the text promoting the lead story. The photograph, by Mark Seliger, depicts a serene scene with the statesman in informal mode, casually dressed, striking a relaxed pose while staring thoughtfully out across the Alaskan seascape. It feels like a retirement photo, with Obama perhaps reflecting philosophically on his years in power.

Issue 1245
October 8, 2015

Rollin Stone

Smash 'Hamilton'

Obama's
Climate
Crusade
The Rolling Stone
Interview

INSIDE: A 14-PAGE SPECIAL REPORT ON OUTSOURCING AND OFFSHORING

The Economist

China and Japan edge closer to war

France's military gamble in Mali

Is the euro zone out of danger?

How children succeed

Aaron Swartz, data liberator

JANUARY 19TH–25TH 2013 Economist.com

How will history see me?

This cover of *The Economist* magazine was published as President Obama embarked upon his second term in office — but it could easily have been the cover for his 2017 departure. The headline sums up what the president might be thinking as he leaves office after a turbulent eight years in charge. It is also the topic that numerous authors, journalists and commentators are considering right now, and will continue to review in the years that follow his exit from the Oval Office. The photograph shows Obama preparing for an official function, adjusting his tie in an oval-shaped mirror. As he looks at himself in the glass, the cover line "How will history see me?", could perhaps be more poignantly reflected back as, "How will I see myself."

This picture was taken on Tuesday January 19, 2010, by *Time* photographer Callie Shell, who trailed Barack Obama during his 2008 election campaign. The image was captured on the eve of the president's first full year in office, and shows him seated behind his desk at the White House, looking pensive. The simple cover line, "Now What?" cleverly sets up the edition's lead story — about what Obama's next moves could, and should be, as he approached his second year of office. The captured pose suggests that he is not sure, or that he is somehow stuck in procrastination. This same composition and headline are also very relevant to the present — to the impending next chapter of Obama's life, now that he has achieved what many thought impossible in becoming the country's first African American president. What does the future hold for him now? Only time will tell, as the final assessment of his presidency will take years to fully define itself.

Until then, goodbye Mr President.

INSIDE: THE REBUILDING OF HAITI

TIME

NOW WHAT?

Obama Starts Over

BY JOE KLEIN

**TUESDAY, JAN. 19
12:41 p.m.**

Obama on the eve of
his first anniversary in
office and just hours
before the result of the
Massachusetts election

**Photograph
by Callie Shell**

"Beautiful."
Vogue

Ben Arogundade's

Black Beauty

The Story Of Black Hair &
Beauty Through The Ages

"Sumptuous, intelligent, insightful."
Essence

Sex, Drugs & Civil Rights

The Story Of Donyale Luna:
Fashion's First Black Supermodel

Ben Arogundade

"Excellent"
The Sunday Telegraph

Ben Arogundade's

Faster Than Jesse Owens

The Story Of Sprinter Eulace Peacock
& The Battle For 1936 Olympic Games

Ben Arogundade's best-seller tracks the evolution of black hair and beauty culture within the media and society, from antiquity to the present.

She lived fast, died young. Donyale Luna, the first black supermodel, broke through fashion's racism during the 1960s civil rights movement.

The backdrop to the so-called 'Nazi Olympics' of 1936 saw two of America's fastest sprinters battle it out for selection at the games.

"A Transformative Remix"
The Times

Ben Arogundade's

Shakespeare Mashup

Othello & Romeo & Juliet Reimagined

"Bold Innovations"
The Observer

The Sexual Language Of Strangers

"A clever, dark drama."
Esquire

Ben Arogundade

The text from Shakespeare's *Othello* and *Romeo & Juliet* is deconstructed and then woven back together to create a new play.

Ben Arogundade's debut novel tells the story of a group of men recruited into a bizarre sex game by a mysterious millionaire.

ABOUT THE AUTHOR

Ben Arogundade is a writer, publisher and entrepreneur. He is one of eight children born in London to Nigerian immigrants who settled in the capital in 1961. He originally trained as an architect before diversifying into graphic design and freelance journalism, where he wrote features for a range of international publications.

A stint as a model became the catalyst for his first book, *Black Beauty* – an illustrated exploration of society's historical perceptions of the black image. The title was honoured by the New York Public Library and became the subject of a three-part BBC documentary. Alongside his written work Ben also works as a voiceover artist across commercials, documentaries and TV and radio dramas.

In 2016 Ben launched his own fledgling media company specialising in books and apps. 365 Positivity aggregates health and wellbeing information into a series of self-help apps, while his publishing imprint, White Labels Books, creates print-on-demand, direct-to-consumer fiction and non-fiction. *Obama: 101 Best Covers* is its debut release.

Discover more about *Black Beauty* at arogundade.com

whitelabelsbooks.com

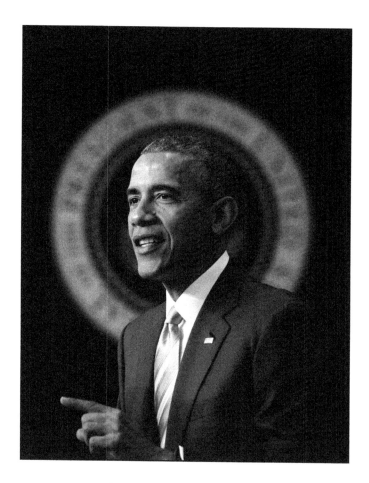

ABOUT THE FRONT COVER

President Barack Obama speaks at the fifth anniversary of the Affordable Healthcare Act, at the South Court Auditorium of the Eisenhower Executive Office Building, Washington DC, on March 25, 2015.

The cover is one of four different executions presented with this book.

Photo by Alex Wong.
©Alex Wong/Getty Images.

COLLECT THE OTHER COVERS IN THE SET

CPSIA information can be obtained
at www.ICGtesting.com
Printed in the USA
LVOW06*1509281217
561091LV00032B/963/P